FORGIVE
EVERYONE EVERYTHING

LOYOLA PRESS.

Chicago

GREGORY BOYLE

New York Times Bestselling Author of *Tattoos on the Heart*

FORGIVE
EVERYONE EVERYTHING

ART BY FABIAN DEBORA
Executive Director Homeboy Art Academy

A Note to the Reader: The anecdotes in this book have been drawn from Gregory Boyle's previously published works from Simon & Schuster, including *Tattoos on the Heart, Barking at the Choir,* and *The Whole Language.* For more details, please see the Acknowledgments and Sources on p. 109.

Text copyright 2022 by Gregory Boyle
Art copyright 2022 by Fabian Debora

ISBN: 978-0-8294-5024-8
Library of Congress Control Number: 2022933949

To purchase this book in bulk quantities, contact Customer Service at 800-621-1008 for information and discounts.

LOYOLA PRESS.

www.loyolapress.com

Printed in the United States of America
22 23 24 25 26 27 28 29 30 31 CGC 10 9 8 7 6 5 4 3 2 1

FABIAN 13

FORGIVE EVERYONE EVERYTHING

Dear Reader,

Sometime ago, I saw a bumper sticker that read **"Forgive everyone everything."** That can be a pretty freeing idea if we can actually live it.

Forgiveness is about restoration of life; it's about becoming whole again, about repairing broken relationships. It's about resilience. And resilience is about bouncing back and allowing yourself to be restored so that things in life don't topple you. We all know what it's like to have our hearts hardened by resentment. **But if we can forgive everyone everything, then we can be freed from anger, hatred, and resentment.**

Psychologists might say that resilience is about perception. Being resilient is about how you choose to see. Long after experiencing a traumatizing event, you can continue to see that event as traumatizing, and it will be traumatizing. Or you could see that event as an opportunity for growth and learning.

There's no denying how difficult things can be. But the way out to the place of resilience, the place of restoration, the place of not allowing your heart to be hardened by resentment, relies on one thing: *forgive everyone everything.*

Fr. Greg

RESILIENCE

On a Saturday in 1996 I am set to baptize George at Camp Munz. He delays doing this with the other priests because he only wants me to do it. He also wants to schedule the event to follow his successful passing of the GED exam. He sees it as something of a twofer celebration. I actually know seventeen-year-old George and his nineteen-year-old brother, Cisco. Both are gang members from a barrio in the projects, but I have only really come to know George over his nine-month stint in this camp. I have watched him move gradually from his hardened posturing to being a man in possession of himself and his gifts. . . .

The Friday night before George's baptism, Cisco is walking home before midnight when the quiet is shattered, as it so often is in his neighborhood, by gunshots. Some rivals creep up and open fire, and Cisco falls in the middle of St. Louis Street, half a block from his apartment. He is killed instantly. His girlfriend, Annel, nearly eight months pregnant with their first child, runs outside. She cradles Cisco in her arms and lap, rocking him as if to sleep, and her screams syncopate with every motion forward.

I don't sleep much that night. It occurs to me to cancel my presence at the Mass the next morning at Camp Munz to be with Cisco's grieving family. But then I remember George and his baptism. When I arrive before Mass, with all the empty chairs in place in the mess hall, there is George standing by himself, holding his newly acquired GED certificate. He heads toward me, waving his GED and beaming. We hug each other. He is in a borrowed, ironed, crisp white shirt and a thin black tie. His pants are the regular, camp-issue camouflage, green and brown. I am *desvelado*, completely wiped out, yet trying to keep my excitement at pace with George's.

"[P]ray for one another, so that you may be healed."

—James 5:16

2

At the beginning of Mass, with the mess hall now packed, I ask him, "What is your name?"

"George Martinez," he says, with an overflow of confidence.

"And, George, what do you ask of God's church?"

"Baptism," he says, with a steady, barely contained smile.

It is the most difficult baptism of my life. For as I pour water over George's head: "Father . . . Son . . . Spirit," I know I will walk George outside alone after and tell him what happened.

As I do, and I put my arm around him, I whisper gently as we walk out onto the baseball field, "George, your brother Cisco was killed last night."

I can feel all the air leave his body as he heaves a sigh that finds itself a sob in an instant. We land on a bench. His face seeks refuge in his open palms, and he sobs quietly. Most notable is what isn't present in his rocking and gentle wailing. I've been in this place before many times. There is always flailing and rage and promises to avenge things. There is none of this in George. It is as if the commitment he has just made in water, oil, and flame has taken hold and his grief is pure and true and more resembles the heartbreak of God. George seems to offer proof of the efficacy of this thing we call sacrament, and he manages to hold all the complexity of this great sadness, right here, on this bench, in his tender weeping. I had previously asked him in the baptismal rite, after outlining the contours of faith and the commitment "to live as though this truth was true." "Do you clearly understand what you are doing?"

And he pauses, and he revs himself up in a gathering of self and soul and says, "Yes, I do."

And, yes, he does.

In the monastic tradition, the highest form of sanctity is to live in hell and not lose hope. George clings to his hope and his faith and his GED certificate and chooses to march, resilient, into his future.

3

LOVE GOODNESS

I have baptized all of Horacio's kids, and today it's number five. I watch Horacio masterfully corral everybody, the kids, the *suegra* (mother-in-law), and his siblings, and deftly bring the proceedings to order. He's a pro. A scrappy gang member with overly pronounced ears—he's so skinny it makes you wonder how he managed to defend himself on the streets. (Trust me, he managed.) Once I saw him and his kid brother, many years ago, in the middle of the day walking in the projects. I asked Horacio if he had ditched school that day. He was insulted. "Noooo," he said, "we didn't ditch school—we just didn't go." My apologies.

"In the same way, let your light shine before others, so that they may see your good works and give glory to your Father in heaven."

—Matthew 5:16

ly said of Horacio, "He is a mansion. He has many rooms." Horacio

winding down the baptism, I am filled with the utter fullness of
ecall Mary Oliver's words: "That you have a soul—your own, no one
nore than I wonder about my own. So that I find my soul clapping
my own." Indeed, Horacio is the whole accomplishment, and my

ptismal photographs, I call him aside. I'm brimming with such love
ogged many years of memories and heartaches.

ng about . . . all during the baptism?"

s?"

asectomy."

nking . . . how thoroughly good you are and what a beautiful job
rio."

ed when we allowed the soul to quicken at hearing what it didn't

h a sense of clarity as to what we are to DO with our lives, gener-
To love mercy. To walk humbly with your God." I saw a translation
ond part this way: "To love goodness." It suggests that love is more
n't want Horacio to meet his potential (or even get a vasectomy).
goodness. Our deep center is indeed saturated with divinity. Love
discovery is that we are the magnanimity of God. **Then it is no
longer about "doing good" but loving goodness.**

WHAT IT MEANS TO BE FAITHFUL

I make my way to Pelican Bay State Prison at the top of the state of California, near the Oregon border. The Catholic chaplain, a gentle soul named Sam, has made the arrangements. Pelican Bay has long been considered the repository of the "worst of the worst." It has forever been the last stop of all the stops. Sam walks me through a segregated unit, one-man cells, holding the most "incorrigible." He announces me to the cell ahead: "It's Father Greg from Homeboy Industries." Many become little kids in Juvenile Hall again. "G-Dog, remember me. You used to throw Mass at Central . . . at Eastlake?" After Sam would announce me, I would step up and carry on a brief conversation and end with a blessing. . . .

I celebrate Mass in the gym on A-Yard. Sam has secured a large group to gather and has also been allowed to take pictures, which is not a permission typically granted. After Mass, inmates pose with me—one, four, sometimes groups of twelve or more. I meet a guy named Louie with every inch of his face covered in tattoos, a calling card for a seriously traumatized human being.

"YOU ARE MY SON, THE BELOVED..."

—Mark 1:11

Tattoos like this can often be a "Keep Away" sign, meant to keep all comers guessing as to the mental stability of the tattooed one. Louie "has all day," sentenced forever and will never leave prison alive. He is goofy and charming, and not at all off-putting. He becomes the phantom, ever-present photobomber. He manages to insinuate himself into EVERY picture. Though never invited, he steps into the shot, and no one rebuffs him. He's just a tender part of the scenery.

As Sam and I walk from the gym after Mass, I mention Louie and laugh about our intrepid photobomber. Sam tells me that some months earlier, he had planned a concert by Eric Genuis. Eric has performed at Carnegie Hall (and later, at Homeboy Industries). He plays the piano and has a couple others who accompany on strings. Sam had "ducated" (secured permission) for two hundred inmates, but only sixty showed up and Sam was a bit disappointed. Eric had planned to play for forty-five minutes, then engage in a question-and-answer session for fifteen minutes. He began to play, and something descended on these folks gathered in the same gym where I had celebrated the Eucharist. There was a reverent stillness thick in the air. Inmates and guards alike were held in this music's spell. It was the most glorious thing Sam had ever witnessed at Pelican Bay. He looked at the prisoners and soon they were all sobbing. He saw that the guards were discreetly flicking tears. The magnificent music had detonated some release so welcome and unexpected.

Eric finished and turned to his stunned audience and asked if there were any questions. There was only silence for some time. Then Louie, our photobomber, rose. He had something to say but he was still crying so hard, it was momentarily a struggle for him to locate his question. He could only utter one word: **"Why?"**

Eric began to cry as well and said, "Because you are deserving. You are worthy of beauty and music. And because . . . there is no difference between you and me." And here, I suppose, is the faith that saves . . . when we are anchored in love, tethered to a sustaining God and ever mindful of our undeniable goodness. **That's why.**

GO WHERE THE JOY IS

"You show me the path
of life.
In your presence there is
fullness of joy;
in your right hand
are pleasures
forevermore."

—Psalm 16:11

Ramoncita was legendary in the Dolores Mission community. I think she was 103 when she died. When she was a spritely ninety-nine, she did the readings often at the daily Mass. She was so tiny that she needed to pull out this portable step tucked into the ambo. She moved quite quickly and with a storehouse of energy as she galloped in her pink tennis shoes to read. Once she elevated herself behind the podium, she turned to the tabernacle behind her, winked at it, and saluted, like she was the president descending the stairs of Air Force One. When she was done, she lowered herself from the step, turned again to the tabernacle, and shot both arms energetically in the air, like she was announcing some gospel touchdown. And she did not own a single tooth in her head. It made the readings a challenge for the congregation but never hampered her resolve to deliver the message.

The word was that Ramoncita had at one time sported perfectly aligned dentures, until one day in the projects she spotted a young mother trying to corral her kids. This mother had no teeth. **Ramoncita approached her, pulled the entirety of her dentures out of her mouth, and said, "Clean these up, they should work fine. You need them more than I do."**

At the end of the letter of James, he writes, **"Let your yes mean yes."** There's "yes" for you, with authentic clarity. And all of it out of doors.

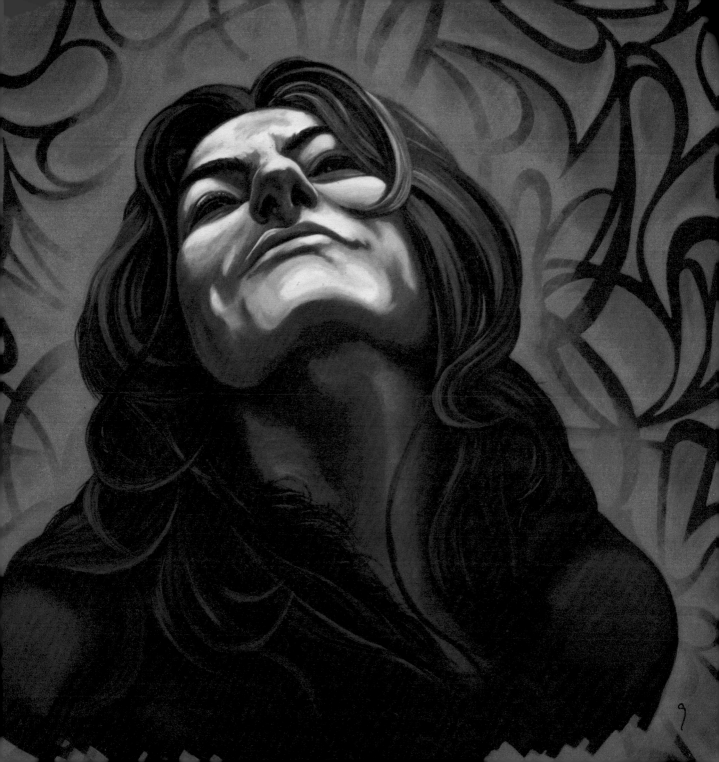

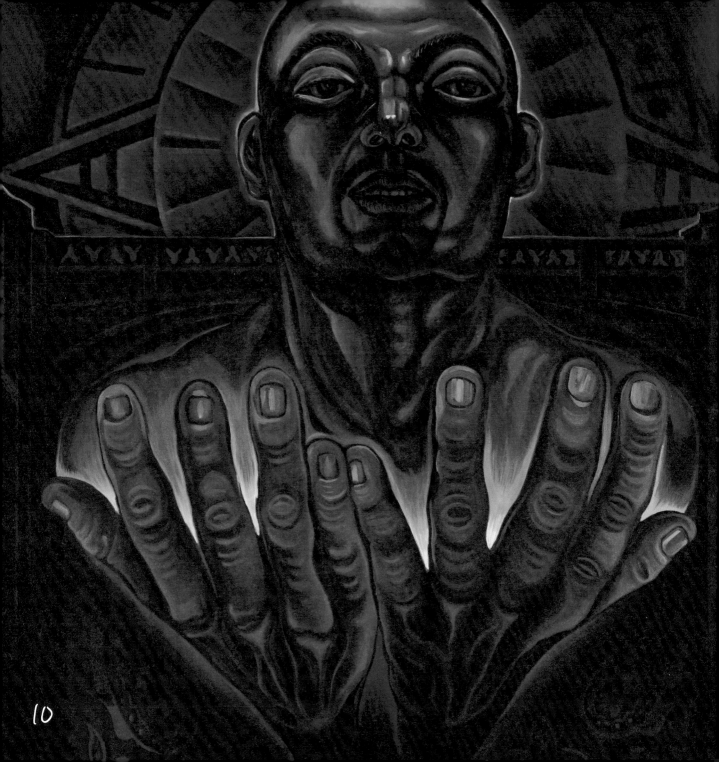

10

LOVE'S ENERGY

At Homeboy, folks are, as the poet says, "won by warmth, ripened affectionately." I got a text from a homie: "I've decided to live in love's energy—now I come to work and my heart smiles. I walk in the door at Homeboy and there it is—the aroma of kinship." Homeboy started with a vision, but then we had to build a belief system. **The fundamental ethos of Homeboy is "walking with"** in love's energy, not "doing for." Shirley Torres says, "The magic happens in the lobby, nearest the swinging of the door." We all walk in the door and, together, stare at our own shared ruin, and we choose to walk as kin. We find a new, spacious way of seeing. I suppose it plans for the future, but it mainly suggests that we not worry about it. . . .

In the culture of tenderness, homies "detoxify" and discover the authority of their own voice, and their true and sacred selves. In the process, they find a love that can go anywhere it wants. Gang members are keenly aware of the limits of geography. "I can't go there," a homie might say. "You crazy? I'll get caught slippin'." What we hope homies will find in a culture of kindness is that **love can be its own passport.**

"Love is patient; love is kind; love is not envious or boastful or arrogant or rude. It does not insist on its own way; it is not irritable or resentful; it does not rejoice in wrongdoing but rejoices in the truth. It bears all things, believes all things, hopes all things, endures all things.

Love never ends."

—1 Corinthians 13:4-8

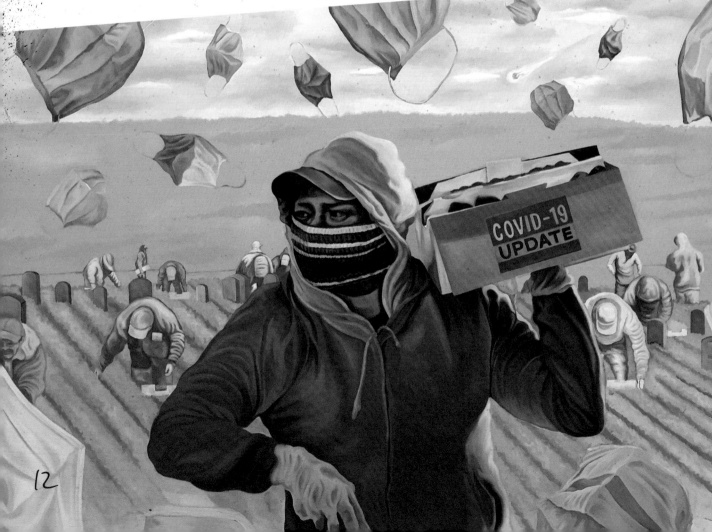

During the early months of the pandemic, before we settled into whatever needed settling, we all kept choosing to be each other's PPE. "Come on, Pops," a homie, Jojo, said. "You and me—we've been through pandemics before." I knew what he meant. We had been through storms and catastrophes and the darkest moments of gang violence. "I'm always gonna be there for you," he added, "through thick or thin, sharp or pointy." I felt "personally protected" by his kindness. Homies had great, liberating humor in memes they sent and texts they'd write. "NOW, can I FINALLY take a shower, or do I have to just keep washing my hands?"

Breaking points happened with some regularity during the plague as well. "I think I'm going to lose it," Lisa tells me.

I say, "No, you're not. You're going to gain it. And I don't mean gain weight from all the crap we're eating on lockdown. **You're going to gain a deeper anchor in love.** Watch. You will gain something beautiful during this time."

A homie, Ricky, one of my "dearly deporteds" in Tijuana, emails me. I don't hear from him very often. Before he went to prison and then got deported, he was having a hard time at home. "I lived in a house where we didn't take out the garbage, we brought it in." His alcoholic father was beyond strict. *"Aquí mando yo"*—which basically means, "This is my house, my rules." Ricky was explaining this to me: "So I had to jump through the loopholes." He was telling me once how he's clear with enemies. "First, I talk, but then, you know, if the situation. . . evaluates . . ." I knew what he meant. He added somberly: "You know what my problem is? I don't got no destination." He ended up doing time for drug sales. He writes me this morning, as we are all on house arrest during the early days of the virus. He writes simply this, in bold letters: "WE ARE YOUR MASK." Which is to say, I suppose, "We got ya; we have you surrounded; come out with your hands up; we will be your protective gear, till the wheels fall off. Sharp or pointy." I understood him. It got me through that day. I felt held and protected.

13

SPIRITUAL EXERCISES

In the Spiritual Exercises, Ignatius talks about "mutual help." It means that I will only know God in entering the life of another and they in me, exquisitely mutual. God just "kicks it," hides in that exchange. **We choose to be what Pope Francis calls "social poets,"** those anchored at the margins who imagine ways forward in this thrilling mutuality. This is how we are reminded that we are children of a vulnerable God. In the *sangha,* in the community of kinship, I see everyone in me and me in everyone. It takes time for folks, until, that is, they find relief and a safe haven. I suppose we still think that "when the student is ready—the teacher will appear." But at Homeboy, **we want the place itself to be the teacher.**

"Keep on doing the things that you have learned
and received and heard and seen in me,
and the God of peace will be with you."

—Philippians 4:9

14

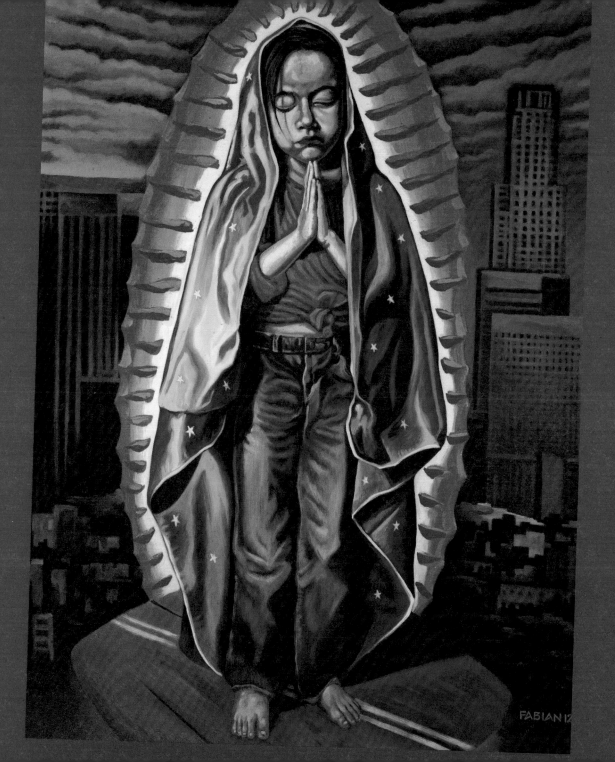

FABIAN 12

15

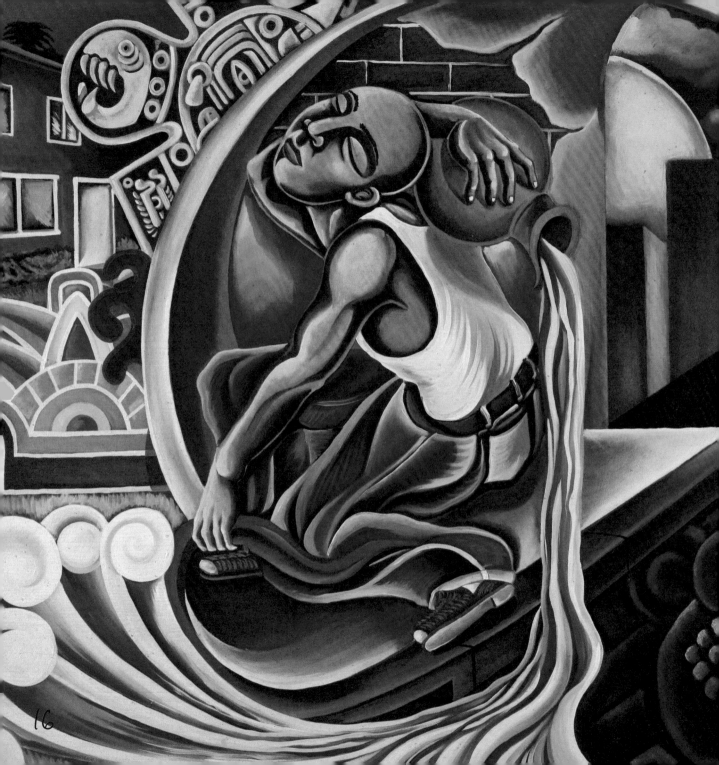

MORE THAN SPIRITUAL

Some man said to me once, "I want to become more spiritual." Yet God is inviting us to inhabit the fullness of our humanity. God holds out wholeness to us. Let's not settle for just spiritual. We are sacramental to our core when we think that every-thing is holy. The holy not just found in the supernatural but in the Incarnational here and now. **The truth is that sacraments are happening all the time if we have the eyes to see.** Limiting them—seven for men, six for women—does not advance the kinship of God. In the time of Jesus, some people said, "No new gifts—we 're okay with the old ones." **The mystic is rapturous and ferociously attentive to the new gifts that show up every day.**

> "I do not judge anyone who hears my words and does not keep them,
> for I came not to judge the world,
> but to save the world."
>
> —John 12:47

17

REJOICE

> ## "Sing praises to the LORD,
> ### O you his faithful ones,
> and give thanks to his holy name.
>
> For his anger is but for a moment;
>
> his favor is for a lifetime.
>
> ### Weeping may linger for the night,
> ### but joy comes with the morning."
>
> —Psalm 30: 5-6

We talk about the Incarnation being necessary. Indeed, it was. Not because of sin—for God's sake. But because God's love needed to become tender. There was an urgency for it to become touch and smell and action and listening; to become tenderness in the flesh.

I wanted to get to the Oakland airport from San Francisco. If you want to know which BART train to get on, you don't need to know your destination (Oakland Airport). You need to know your train's final stop. Only trains that end in "Fremont" will get you to the airport. Our final stop, as Jesus suggests, is joy. "My joy yours, your joy complete." All roads lead to joy. Teresa of Ávila got this one right: "Just these two words God spoke changed my life: 'Enjoy Me.'" That's the Fremont train.

Jesus invites us to joy. The holiness to which we are called is to know joy in its fullness. We let ourselves be drawn to the Tender One whose face is unbridled joy. We are beckoned to this locus of joy, not a reckoning with the error of our ways but God saying, unabashedly smiling, "Get over here."

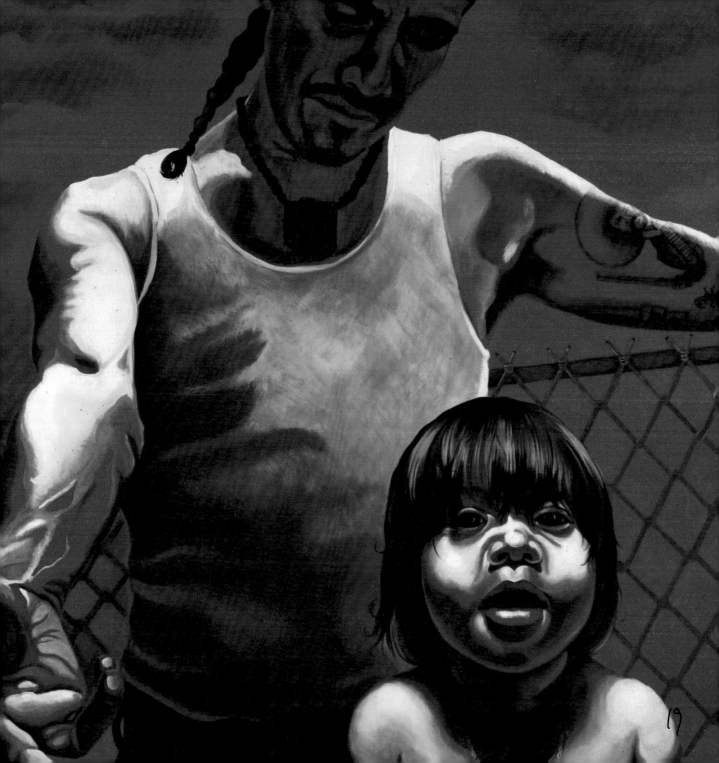

RELISHING

Pedro Arrupe thought that the daily pursuit of delight should be our focus. He used words like "rejoicing" and "relishing." These are the things that shape our soul and lodge it in an intimacy that is real and replenishing.

Relishing can take an odd form as well. A homie, fresh out of a long stretch in prison, says to me: "Now I'm out, and I can bury my own people." He is able to rejoice in this new freedom and ability. A lifer released after thirty years sends a video to my cell phone on the Fourth of July of fireworks seen from his back porch. There are the sounds of fireworks in the distance, of course, but close at hand, you mainly hear "Ooooooh! AAAAAHHH!!!" It's the homie relishing this moment, and I replayed it several times. It made me cry each time. A homie, accompanying me on a cross-country flight, turns to me, seat-belted and ready for takeoff: **"I plan on smiling all the way to Boston." Limitless relishing.**

> "May the God of hope fill you with all joy and peace in believing, so that you may abound in hope by the power of the Holy Spirit."
>
> —Romans 15:13

The aspiration here is to the limitless. What we discover is that there is a reservoir of love within us and this simply won't dry up. I had known Chepe for thirty years and he was in prison for these past twenty. He never once wrote me in all that time. Then he does.

His letter is both a little rusty on the news and surprising. "I hear you have cancer. Sorry to hear that. I hope you get better." Then he changes lanes. "On a lighter note, I heard you got married. Congratulations." Knowing that we have access to this source of love brings us true joy. Limitless reservoir. So, we settle into this loving luminosity that allows us to accept everything and abide and rest in it without attachment and struggle. We can relish then . . . every . . . single . . . thing.

Fearlessness will always be a contour of our ultimate joy and transformation. We don't sidestep our fear and underlying sadness, we allow acceptance of it all, and then we can connect to our pathway to joy. A scrappy twenty-year-old Black gang member named Jason confided, "I didn't have a childhood. So, I'm not gonna lie. I still watch cartoons and eat cereal. Trying to relive a childhood—that I didn't have." For in the end, it's only our joy that authenticates our living, brought to you by a decided fearlessness. "One filled with joy," Mother Theresa says, "preaches without preaching." In good times and in bad. Eating cereal and watching cartoons. Smiling all the way to Boston. Turns out, joyful people are holy people.

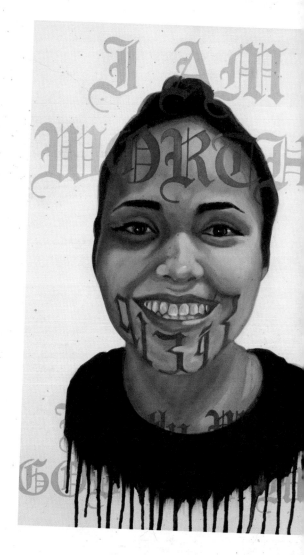

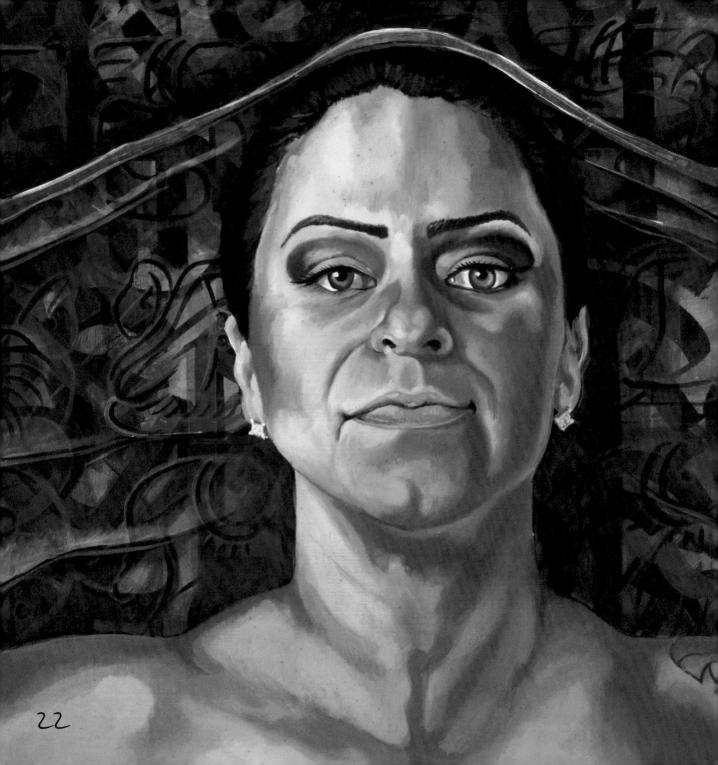

22

BE ON THE LOOKOUT

My friend Mirabai Starr, a mystic who writes about mystics, says, **"Once you know the God of Love, you fire all the other gods."** It is always hard for us to believe in the nonjudgmental, loving, and merciful God, and yet, that is the God we *actually* have.

Joel, a man who did considerable time in prison, told me, "When my toes hit the floor in the morning, I'm on the lookout."

"On the lookout for what?" I asked him.

"For God," he said. "God is always leaving me hints. He's dropping me anonymous tips all the time." This is the God of love trying to break through. This God will not be outdone in extravagant tenderness. Leaving hints as "deep as the nether world or high as the sky," as the prophet Isaiah reminds us. We get to choose: **the god who judges and is embarrassed, or the One who notices and delights in us.**

> "In past generations he allowed all the nations to follow their own ways;
> yet he has not left himself without a witness in doing good—
> giving you rains from heaven and fruitful seasons, and filling you with
> food and your hearts with joy."
>
> —Acts of the Apostles 14:16-17

23

MASTERPIECES

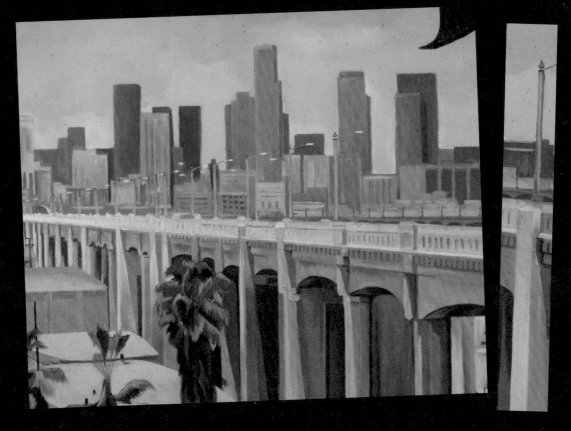

"The angel said to them, 'Do not be afraid; for see—

I am bringing you good news of great joy for all the people . . .'"

—Luke 2:10

Anthony is in his mid-thirties and in his tenth month as a trainee at Homeboy Industries. He and his wife have three very young daughters. He was mainly missing in action for the birth of his first two. When the third is born, he holds her in his arms and tells me later, "Damn, G . . . I looked at her face and I thought, 'She looks exactly like her mother—angry.'" We laugh.

Half of Anthony's life had been spent in jails and detention facilities. Before coming to us, a meth addiction crippled him surely as much as his earlier gang allegiance did. We're speaking in my office one day and he tells me that he and his twin brother, at nine years old, were taken from their parents and a house filled with violence and abuse and sent to live with their grand-mother. "She was the meanest human being I've ever known," Anthony says. Every day after school, every weekend, and all summer long, for the entire year Anthony and his twin lived with her (until they ran away), they were forced to strip down to their *chonies,* sit in this lonely hallway "Indian style," and not move. "She would put duct tape over our mouths . . . cuz . . . she said, 'I hate the sound of your voices.'" Then Anthony quakes as the emotion of this memory reverberates. "This is why," he says, holding a finger to his mouth, "I never shush my girls." He pauses and restores what he needs to continue. "I love the sound . . . of their voices. In fact, when the oldest one grabs a crayon and draws wildly on the living room wall and my wife says, 'DO something! Aren't ya gonna TELL her something?' I crouch down, put my arm around my daughter, and the two of us stare at the wall, my cheek resting on hers, and I point and say, 'Now, *that's* the most magnificent work of art . . . I have ever seen.'"

Here is the Good News: **The God we most deeply want IS the God we actually have,** and the god we fear is, in fact, the partial god we've settled for. God looks at us and is ecstatic. This God loves the sound of our voices and thinks that all of us are a magnificent work of art. "You're here." God's cheek resting on ours. **God's singular agenda item.**

25

LOVE ALL THE TIME

Since God persists in love, no matter how dark things get, God is not preoccupied nor enfeebled by our "sin." This is true because God doesn't see sin but wholeness. God sees right through it. A homie texted me, sending a YouTube homily by a bishop who spoke of sin and the need for a "contrite heart." This gave the homie a passageway to deem himself, really, "a worthless piece of shit." I texted back only this: "God doesn't see sin. God sees son." The relief in his next text was palpable. His notion of sin was self-estranging. He wanted to accept that he was "son" but didn't know how to dare to believe it.

Erich Fromm says we have two main fears: losing control and becoming isolated. During World War C (the COVID-19 pandemic) while we were all staying at home, these fears got activated. But the homegirl Carizma texted me during our house arrest: **"Yeah . . . love is stronger than any virus."** Everyone asked themselves: "Is that true?" How quickly the answer came: "Yes. Of course it is." So, we set out on the task articulated by Teresa of Ávila: **"I have stepped from that region of me that did not love all the time."** The antidote to our fears is to live in the "region" of that singular focus.

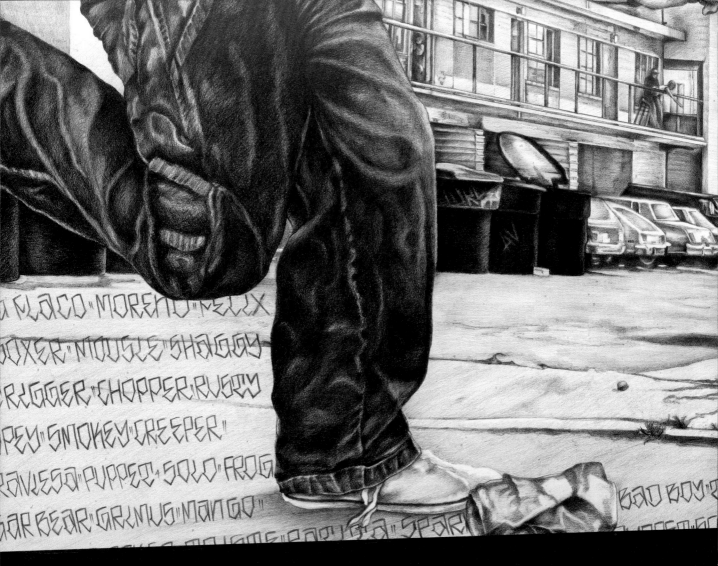

"There is no fear in love,
but perfect love casts out fear; for fear has to do with punishment,
and whoever fears has not reached perfection in love."
—1 John 4:18

27

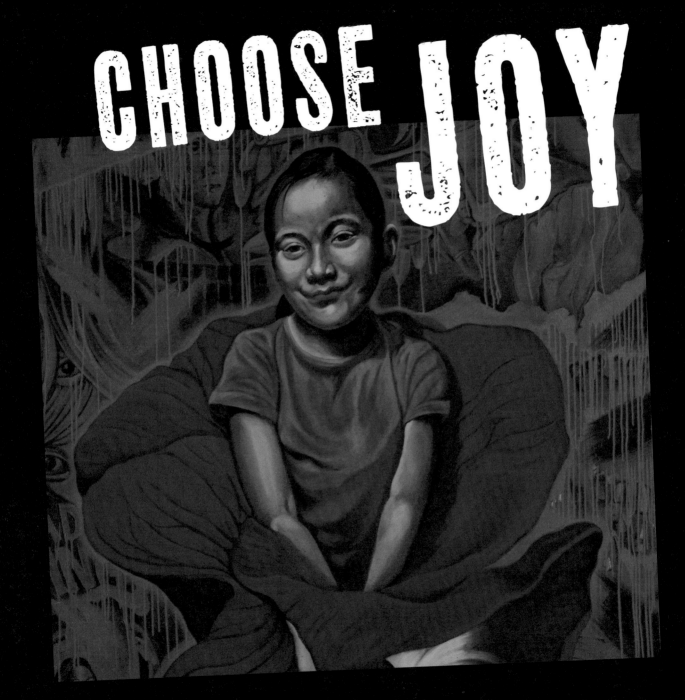

Intention is the most powerful ability that human beings have. We decide to be tender. We arrive at the clear intention to be tender and it catapults us out of our default mode, which is self-absorption. You find this on planes. Everyone is battling to get their carry-on into the overhead compartments. They are knocking over folks to secure the spot. No fewer than three times, the flight attendant announces that folks should "step out of the aisle" and let others pass. Three times. People aren't selfish. We aren't sinful. We aren't jerks. We are unshakably good. But sometimes we are simply self-absorbed, trapped in the small self. If you make your tender heart your highest priority, then you focus on the other. Try this on a plane. Joy ensues.

Joy has to include everything; otherwise it remains shallow and a whim of only the good times. We can't allow our joy to be conditional on how things turn out. On April 2, Louie fills out the tattoo removal form. It asks: "Why do you want to remove your tattoos?" He writes: "I just want to be able to walk around freely." An appointment gets made in our tattoo removal clinic for April 15. Two days before his appointment, the receptionist calls to remind him. She is told that he was killed three days before. This reverberated in the Homeboy family for the tragic heart wrench it represented. Joy has to include this. You find it in Louie's longing to "walk around freely." You celebrate that longing that had already freed him.

It is precisely because we so fundamentally doubt that we are worthy of love that we find it difficult to traverse the terrain of our vulnerability so that we can choose joy. This is the gentle soft spot that can reach across and connect finally with the other, to make the shift from protected heart to vulnerability. The homies discover tenderness as their weapon of choice. To be grounded in our "tenderoni" self is to know that we will endlessly struggle with our worthiness to be loved. **Turns out, this is a necessary ingredient to being courageously tender with other people and is the door that opens to joy.**

"But let all who take refuge in you rejoice;
let them ever sing for joy.
Spread your protection over them,
so that those who love your name may exult in you."
—Psalm 5:11

29

YOU'RE HERE

"[The] father said to him,

'Son, you are always with me, and all that is mine is yours.'"

—Luke 15:31

A few years ago, I buried my ninety-two-year-old mother. She died as we would all want to: in her own bed, in her own home, surrounded (off and on) by her eight kids and many grandchildren. I had buried my father some twenty-two years earlier. My mom was sharp till the last moment. In fact, in the last year of her life, she watched so much MSNBC she was becoming Rachel Maddow. And she was not a lick afraid of dying. Some three weeks before she died, she said to me, giddy and exhilarated, **"I've never DONE this before."** It was something you'd say just before skydiving.

In fact, the day before she died, I was alone with her, the rarest of things, and she was asleep. When her eyes opened and she saw me there, she scowled. "Oh, for cryin' out loud." And she closed her eyes. She was pissed . . . that she wasn't dead yet. (Sorry.) But the next day my sisters went out to retrieve lunch and I was alone with her again, sitting at the foot of the bed. At exactly noon, she opened her eyes, lifted her head some, let out a glorious, wondrous gasp (skydiving), and she left us. And no one in earshot of the sound would ever fear death again.

During those last weeks, one or two or six of her kids would be keeping vigil around her bed, and she'd be in and out of consciousness. When she came to, she'd lock onto one of us and say with breathless delight, "You're here. You're here."

After we buried her, I recalled this and grew convinced that this may well be the singular agenda item of our God. To look at us with breathless delight and say, "You're here. You're here."

We have this image of Jesus spending forty days and forty nights in the wilderness, the precursor of our forty days of Lent. It supplies us with Polaroids like "dark night of the soul," grumbling stomach, wild wilderness animals, plague of self-doubt, anguish, and torment . . . Jesus wondering if he should have given up BOTH scotch AND chocolate for Lent. Yet I suspect it was all mainly God saying tenderly, "You're here!" and Jesus not really knowing what to say in response but, "YOU'RE here." God meets our intensity of longing with intensity of longing. **Turns out, the Tender One whom we long for longs for us.**

POETRY IN PAIN

A tough homie, Omar, was a "YA baby" (sent as a juvenile to the Youth Authority for a serious crime) who spent twenty years in prison. He was a boxer and quite accomplished in that realm. He loved his therapist at Homeboy and never had any trace of embarrassment in attending his appointments with her. He worshipped his father, who'd dropped dead of a heart attack when he was a tiny boy. Just the two of them were home, and he remembers finding his father dead in a hallway. He thought he was asleep and he was waiting for his dad to take him on a much-anticipated trip to the zoo that day. He saw his father and shook him: "*Apa,* wake up, we're going to the zoo." The father just lay there, and Omar climbed on top and settled in for a nap as well. He slept on his dead father until his mother returned home. As often happens in these abandonment scenes, Omar carried some heavy and unwarranted culpability that festered until gang allegiance replaced it.

At the office, he'd look at his watch and say, "Gotta go see my cuckoo clock doctor." He told me once that his therapist would sometimes just read to this six-foot-three man, *Green Eggs and Ham* or *The Cat in the Hat,* and Omar would just curl up on the couch and sob. **He told me once, "I've found poetry in my pain."**

In the end, all great spirituality is about what to do with our pain. We hesitate to eradicate the pain, since it is such a revered teacher. It re-members us. **Our wounds jostle from us what is false and leave us only with a yearning for the authentically poetic.** From there to here. Holiness as a contact sport, busting us open into some new, unfettered place. We are hesitant, then, not to call it God. Remarkable, incredible, and . . . all the other "-ables."

"The LORD builds up Jerusalem; he gathers the outcasts of Israel.

He heals the brokenhearted, and binds up their wounds.

He determines the number of the stars;

he gives to all of them their names."

—Psalm 147:2-4

TABERNACLE

Jeanette rarely asks for an audience. I've known her since her gangbanging days, her getting-high days, and her in-and-out-of-prison days. She has her kids back and is a Navigator. She rarely asks to see me. "You know, G," she says, "I texted you this morning and you didn't get back to me."

It's now nearing 4:00 p.m. and I move quickly into default defense. "Yeah, kiddo—it's been a crazy day, and I get thousands of texts."

Jeanette stops me and even uses her hand to halt my words. "G . . . if you don't text me back"—now she holds her hand to her eyes— "I think . . . you're mad at me." This just slits my heart wide open, and I am on my feet, hugging her, also teary, doing my best to convince her that "mad" is not part of my vocabulary with her, ever.

That evening I had agreed to speak to a combined group consisting of the members of confirmation programs from various parishes. Seven hundred teenagers await my speech. I am standing off to the side, at the front of the church, near the altar, while the catechist is explaining future events and assignments.

I have become the mad texter. With Jeanette's admonition still fresh, I'm getting back to everyone. So many of them say, "G . . .I gotta talk to you." I get ninety-three of those each day. I tell these homies when to come in. The rest I respond to as best and as quickly as I can. "Thanks, son. Hearing from you made my day." "Hey, *mija,* is the baby sleeping through the night?" "Hey, dawg, how'd that job interview go?" I don't stop texting even while the woman introduces me.

After the talk, I'm in the vestibule and folks are crowding around. They say nice things; I shake their hands. I keep turning and signing books. When I turn to a woman on my left, she says, "I'm very disappointed in you." I think, *Oh gosh, here we go.* I ask her why. "The texting." I'm confused. I think she's mentioning a riff I do in my talk on texting and autocorrect, so I suggest

that. "NOOOO." She's quite insistent. "You were texting in front of the tabernacle." It all came into place now.

"Oh," I tell her, gently placing my hand on her arm. "Aren't we lucky to have a God who doesn't care about such things?" And I turn to the next person crushing in.

Here's the thing. I drive home and feel this dark and heavy pressure forcing its way into my consciousness. It's a dread mixed with dis-ease. Then I land on it. My words to this woman. I didn't catch myself and I weaponized my response. I was defensive and I just wanted to win the argument. It reminds me of what restoration I need still, and I feel called to be sculpted anew by the culture of nurturing and cherishing. The mystical view keeps us from justifying how annoyed we are and it topples our self-importance. I wanted to stand with a radically loving and undefended heart. In my mind, I heard myself tenderly apologizing to the woman, acknowledging her pain without judging it as out of step theologically or inconvenient to me.

We talk a lot at Homeboy about transformation. This, of course, requires the fullest cooperation and some mystical and contemplative savoring of everything that happens to us. Even the discomfort of people calling us up short. **The way of our broken, open hearts is to try and respond to the hurt,** not with more hurt but with a nurturing touch. You choose, as part of your practice, a genuine and unconditional positive regard shown to all, even to those expressing disapproval of you.

> **"Then Jesus said, 'Father, forgive them; for they do not know what they are doing.'"**
>
> —Luke 23:34

35

36

ATTENTIVENESS

Poet David Whyte encourages us that **"to remember the other world in this world is to live in your true inheritance."** Paradise, then, is not a place but a full participation in our true inheritance. A Jesuit came back from visiting an old great friend who was dying at home under hospice care. I asked how it went. **"All we did was laugh our asses off. It was a really good use of time."** You dive into your true inheritance. You don't stare at your watch and wait for it to arrive. If we wait to face death on our deathbed, it's too late. The earlier you die, the better. The inheritance is here and now. Then you decide that what is right in front of you is so magically special that you cease to care about what happens next. After all, the Risen Christ cannot be found among the dead. Instead, resurrection locates us in the here and now. Death becomes an eternal alarm clock. Then we can dedicate ourselves to attentiveness. Mary Oliver writes: "This is the first, the wildest, and the wisest thing I know: **that the soul exists and is built entirely out of attentiveness."** We are startled awake to this. It's not just about my own mortality and the fact that everybody's going to die. Death reminds us to make sure every moment is important. In this way, we notice the way God notices.

"Therefore we must pay greater attention to what we have heard, so that we do not drift away from it."

—Hebrews 2:1

37

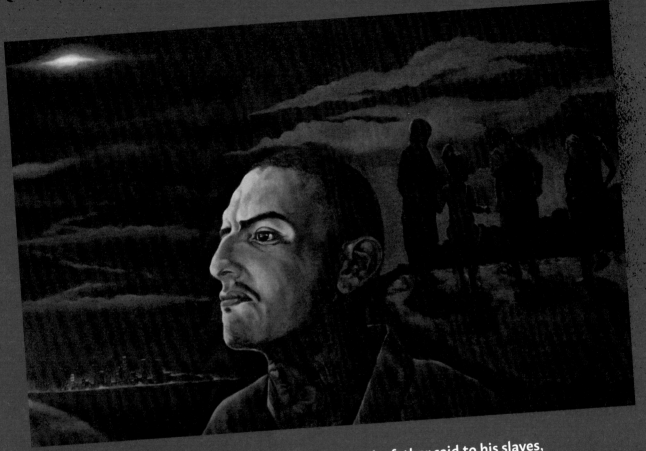

"'I am no longer worthy to be called your son.' But the father said to his slaves, 'Quickly, bring out a robe—the best one—and put it on him; put a ring on his finger and sandals on his feet. And get the fatted calf and kill it, and let us eat and celebrate; for this son of mine was dead and is alive again; he was lost and is found!' And they began to celebrate."

—Luke 15:21-24

NOBILITY

A homie I met in camp expressed a common lament. "I mean . . . my *jefito* (dad) just doesn't get me. He does . . . not . . . understand me. I mean . . . he thinks . . . I'm good." How easy it is to believe and invest in our impoverished identity, to believe that the injured self is who we are. We never want to be who we are. Yet one doesn't "become" noble. We locate our nobility. **The hard part is embracing our inner nobility, beauty, and goodness.** Unfortunately, so often for all of us, it is the frightened, damaged self that takes center stage. We can learn to catch ourselves. The homies think that this is their truth. They get caught in the downward spiral and repetitive cycle of unworthiness and shame. The flip side of this is developing a positive facility for a different way to define. To define oneself in donation rather than deficit. It's not that they have forgotten their original goodness but that they have never been properly introduced to it.

BEAUTY FULL

I guess I met Joker in a probation camp. Hard to retrieve the memory of our first encounter. He's tried a few times to begin our program but has difficulty being in the vicinity of other human beings. He also "blazes it" constantly to calm himself down, so it's hard for him to test clean for us. He's more than a "daily communicant" with me. He texts me at least four times a day. He often shoots me pics of meals he has prepared for himself and shots of his arm donating blood. I always call him my son and try to inch him one step closer to seeing himself as God does. One just keeps hoping against hope that he will find love as his true identity and deepest dignity. There are always glimpses of the movement from isolation to relationship and I watch as Joker's fears get transformed. "I'm fond of you," he texts me once, from left field. I write back: "Well . . . I'm fond of you, too—and I'm grateful to God that you're in my life." His response is immediate: "The feeling's neutral." I'll take it.

There is the greeting "Namaste," which means "I greet the Holy One in you." **I acknowledge the fullness of God and the solid goodness at your core.**

My grandmother had two peculiar pronunciations in her repertoire. She pronounced "spaghetti" like "sperghetti," and the word "beautiful" came out as "beauty-full." As in, "the sperghetti was beauty-full." We see the Holy One, we "train for innocence," we look for the sheer, utter goodness in the other and deem it "beauty-full." **In this, we find the unbearable beauty of our own life. It's there and we can actually choose it.**

> "For it was you who formed my inward parts;
> you knit me together in my mother's womb.
>
> I praise you, for I am fearfully and wonderfully made.
>
> Wonderful are your works;
> that I know very well."
>
> —Psalm 139:13-14

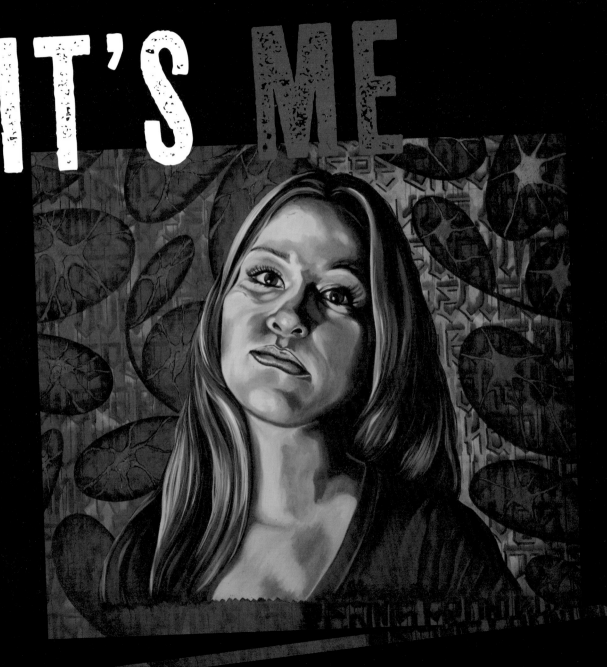

IT'S ME

42

> ## "Do not be conformed to this world,
> but be transformed by the renewing of your minds, so that you may discern what is the will of God—what is good and acceptable and perfect."
>
> —Romans 12:2

Often, a homie will call me and only identify himself in this way: **"It's me."** I told a homie once, "If you had any idea how many 'me's' I know." There's a pause and the guy says, "Wow, G—you used to always know who 'me' was." You really can't win. But the homies always think they need to become a "me" other than the person they are. The problem, of course, **is not that God does not think we are good enough but that we don't know how good we are**. We are distant from this truth. Homies, when they share an emotional experience they once had, instead of saying "I cried," they always say, "Tears started coming out." (Another one said, "I got sweaty eyes.") Distance. We simply can't shake the narrative that we were tossed out of the garden for being bad and our only hope of return is to become good. How do we replace the god who wants us "to get our act together" with the God who just wants us to "get it on"?

"[God's] love thaws the holy in us," Teresa of Ávila said. Love is God's meaning and being. Create a culture of this, then homies can suddenly move from invisibility, from unspecified "me," to the wide-open spaces of our common truth. Kierkegaard writes, **"To be entirely present to oneself is the highest thing and the highest task for the personal life."** They can see as God sees, then be entirely present to that. "Try," as Hafiz tells us, to look "upon yourself more as God does. For He knows your true royal nature, God is never confused and can only see Himself in you." They can move from that miserable place that dissociates from the unspeakable things done to them to the quaint city of their true selves. "My problem is," Mikey says, "that I get new information, but it's processed by the old self." Out with the old. In with the true self. **Wisdom: your best friend.**

43

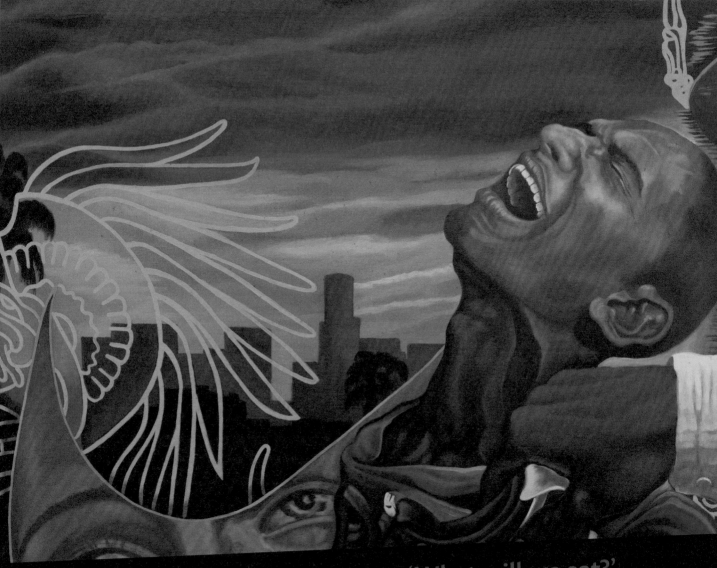

"Therefore do not worry, saying, 'What will we eat?' or 'What will we drink?' or 'What will we wear?' For it is the Gentiles who strive for all these things; and indeed your heavenly Father knows that you need all these things. But strive first for the kingdom of God and his righteousness, and all these things will be given to you as well."

—Matthew 6:31-33

44

FULLNESS

Rascal is not one to take advice. He can be recalcitrant, defensive, and primed for the fight. Well into his thirties, he's a survivor. His truck gets filled with scrap metal, and with this, somehow, he feeds his kids and manages to stay on this side of eviction. To his credit, he bid prison time and gangbanging good-bye a long time ago. Rascal sometimes hits me up for funds, and I oblige if I have them and if his attitude doesn't foul my mood too much.

But you can't tell him anything—except this one day, he actually listens. I am going on about something—can't remember what but I can see he's listening. When I'm done, he says simply, **"You know, I'm gonna take that advice, and I'm gonna let it marinate," pointing at his heart, "right here."**

Perhaps we should all marinate in the intimacy of God. Genesis, I suppose, got it right—"In the beginning, God." Ignatius of Loyola, the founder of the Jesuits, also speaks about the task of marinating in the "God who is always greater."

He writes, "Take care always to keep before your eyes, first, God." The secret, of course, of the ministry of Jesus was that God was at the center of it. Jesus chose to marinate in the God who is always greater than our tiny conception, the God who "loves without measure and without regret." To anchor yourself in this, to keep always before your eyes this God, is to choose to be intoxicated, marinated in the fullness of God. An Algerian Trappist, before his martyrdom, spoke to this fullness: **"When you fill my heart, my eyes overflow."**

45

GUILT AND SHAME

Author and psychiatrist James Gilligan writes that the self cannot survive without love, and the self, starved of love, dies. The absence of self-love is shame, "just as cold as the absence of warmth." Disgrace obscuring the sun.

Guilt, of course, is feeling bad about one's actions, but shame is feeling bad about oneself. Failure, embarrassment, weakness, overwhelming worthlessness, and feeling disgracefully "less than"—all permeating the marrow of the soul.

Mother Teresa told a roomful of lepers once how loved by God they were and a "gift to the rest of us." Interrupting her, an old leper raises his hand, and she calls on him. "Could you repeat that again? It did me good. So, would you mind . . . just saying it again."

Franciscan Richard Rohr writes that "the Lord comes to us disguised as ourselves."

We've come to believe that we grow into this. The only thing we know about Jesus "growing up" is that he "grew in age, wisdom, and favor with God." But do we really grow in favor with God? Did Jesus become increasingly more favorable to God, or did he just discover, over time, that he was wholly favorable?

> "For by grace you have been saved through faith, and this is not your own doing; it is the gift of God."
> —Ephesians 2:8

46

JESUS

Jesus says if you love those who love you, big wow (which I believe is the original Greek). He doesn't suggest that we cease to love those who love us when he nudges us to love our enemies. Nor does Jesus think the harder thing is the better thing. He knows it's just the harder thing. But to love the enemy and to find some spaciousness for the victimizer, as well as the victim, resembles more the expansive compassion of God. That's why you do it.

To be in the world who God is.

Here is what we seek: a compassion that can stand in awe at what the poor have to carry rather than stand in judgment at how they carry it.

> "'Give to everyone who begs from you; and if anyone takes away your goods, do not ask for them again. Do to others as you would have them do to you.
>
> 'If you love those who love you, what credit is that to you? For even sinners love those who love them.'"
>
> —Luke 6:30-32

49

YOU'RE IN THE RIGHT PLACE

Scripture scholars contend that the original language of the Beatitudes should not be rendered as "Blessed are the single-hearted" or "Blessed are the peacemakers" or "Blessed are those who struggle for justice." Greater precision in translation would say, "You're in the right place if . . . you are single-hearted or work for peace." The Beatitudes is not a spirituality, after all. It's a geography. It tells us where to stand.

Compassion isn't just about feeling the pain of others; it's about bringing them in toward yourself. If we love what God loves, then, in compassion, margins get erased. "Be compassionate as God is compassionate" means the dismantling of barriers that exclude.

In Scripture, Jesus is in a house so packed that no one can come through the door anymore. So, the people open the roof and lower this paralytic down through it, so Jesus can heal him. The focus of the story is, understandably, the healing of the paralytic. But there is something more significant than that happening here. **They're ripping the roof off the place, and those outside are being let in.**

> "Be merciful, just as your Father is merciful."
> —Luke 6:36

LOVE

Gangs are bastions of conditional love—one false move and you find yourself outside. Slights are remembered, errors in judgment held against you forever. If a homie doesn't step up to the plate, perform the required duty, he can be relegated to "no good" status. This is a state from which it is hard to recover. Homeboy Industries seeks to be a community of unconditional love. Community will always trump gang any day.

Derek Walcott writes, "Either I am a nobody or I am a nation."

Our place at Homeboy is this touchstone of resilience. You discover your true self in this "nation." Homies who used to work at Homeboy always return on their days off or on their lunch break. A homie said to me once, **"I just came by to get my fix."**

"Of what?" I ask him.

"Love," he says.

Everyone is just looking to be told that who he or she is is right and true and wholly acceptable. No need to tinker and tweak.

Exactly right.

> "Blessed be the God and Father of our Lord Jesus Christ, who has blessed us in Christ with every spiritual blessing in the heavenly places, just as he chose us in Christ before the foundation of the world to be holy and blameless before him in love."
>
> —Ephesians 1:3-4

LOOKING BEYOND

All throughout Scripture and history, the principal suffering of the poor is not that they can't pay their rent on time or that they are three dollars short of a package of Pampers.

As Jesus scholar Marcus Borg points out, the principal suffering of the poor is shame and disgrace. It is a toxic shame—a global sense of failure of the whole self. This shame can seep so deep down. I asked a homie once, after Mass at a probation camp, if he had any brothers and sisters.

"Yeah," he says, "I have one brother and one sister," and then he's quick to add, with emphasis, "but THEY'RE GOOD."

"Oh," I tell him, "and that would make YOU . . . ?"

"Here," he says, "locked up."

"And THAT would make you . . . ?" I try again.

"Bad," he says.

Homies seem to live in the zip code of the eternally disappointing and need a change of address. To this end, one hopes (against all human inclination) to model not the "one false move" God but the "no matter whatness" of God. You seek to imitate the kind of God you believe in, where disappointment is, well, Greek to Him. You strive to live the black spiritual that says, "God looks beyond our fault and sees our need."

"No one who believes in him will be put to shame."
—Romans 10:11

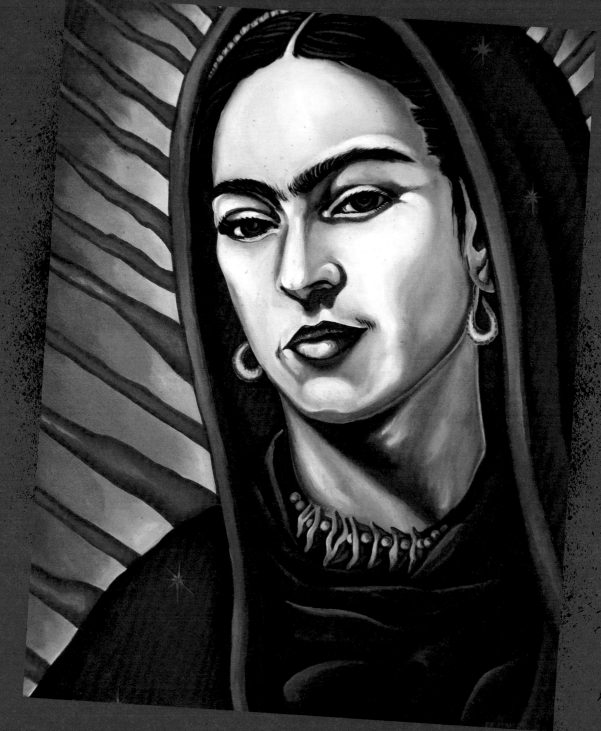

DEFINE YOUR TERMS

In 1993, I taught a course at Folsom Prison: "Theological Issues in American Short Fiction." From the beginning, the inmates said they wanted me to teach them something. Just not Scripture. I mentioned that I had an MA in English.

"Well, yeah, teach us that," they said.

So, we would sit around in the chapel, some fifteen lifers and myself, and discuss short stories. I ended up teaching three classes of this short-story course on all three yards. (As in most prisons in California, they have three yards: A [special-needs yard or protective custody]; B [a tough and generally wild yard]; and C [a moderately "programming" yet very high security yard].)

I settled on short stories so I could Xerox copies of really short ones and we'd read them out loud and discuss them.

One of the stories was Flannery O'Connor's "A Good Man Is Hard to Find." After they read it, we come to the Grandmother's transformation of character ("she would of been a good woman . . . if it had been somebody there to shoot her every minute of her life"). My students speak of this woman's change and seem to use these terms interchangeably: sympathy, empathy, and compassion. **Like any teacher stalling until the bell rings, I ask these felons to define their terms.**

"Well, sympathy," one begins, "is when your homie's mom dies and you go up to him and say, ''Spensa—sorry to hear 'bout your moms.'"

Just as quickly, there is a volunteer to define empathy.

"Yeah, well, empathy is when your homie's mom dies and you say, ''Spensa, 'bout your moms. Sabes qué, my moms died six months ago. I feel ya, dog.'"

"Excellent," I say. "Now, what's compassion?"

No takers.

The class collectively squirms and stares at their state-issue boots.

"Come on, now," I say. "Compassion—what's it mean?"

Their silence is quite sustained, like visitors entering for the first time some sacred, mysterious temple.

Finally, an old-timer, down twenty-five years, tentatively raises his finger. I call on him.

"Well, now," he says, all eyes on him, shaking his head. "Compassion—that's sumthin' altogether different."

He ponders what he'll say next.

"Cause," he adds humbly, "that's what Jesus did. I mean, **compassion . . . IS . . . God.**"

God is compassionate, loving kindness. All we're asked to do is to be in the world who God is. Certainly, compassion was the wallpaper of Jesus' soul, the contour of his heart, it was who he was. I heard someone say once, "Just assume the answer to every question is compassion."

Jesus pulled this off. Compassion is no fleeting, occasional emotion rising to the surface like eros or anger. It's full throttle. Scripture scholars connect the word to the entrails, to the bowels, from the deepest part of the person. This was how Jesus was moved, from the entirety of his being. He was "moved with pity" when he saw folks who seemed like "sheep without a shepherd."

He had room for everybody in his compassion.

"**When he saw the crowds,** he had compassion for them, **because they were harassed and helpless, like sheep without a shepherd.**"
—Matthew 9:36

57

BREATHE IN, BREATHE OUT

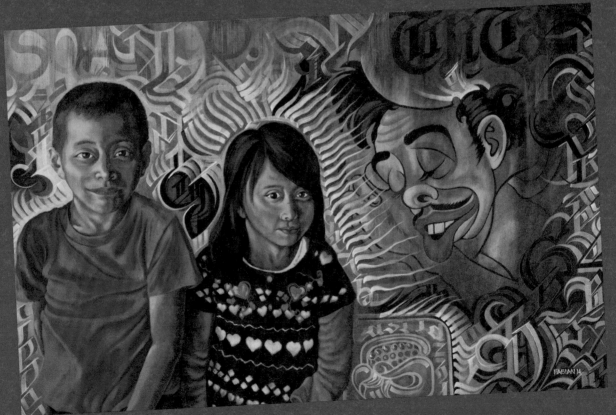

One day, I'm looking for a runner—a homie to take a message to someone else in the building. I look up from my desk and see two homies in the "well" (the sunken computer area in the old office, where phones got answered and data got entered). I spot Mario and Frankie, two big homies, staring at a computer screen intently "working" (though "work" may be too strong a word).

I'm about to call Frankie to be my runner when I observe him lean into Mario's chest and take a deep, deep breath. He exhales contentedly.

"Frankie, come here a minute," I yell at him from my office inner sanctum. He looks cookie-jar startled. Embarrassed, he runs to my office. I hand him the message and instruct him to go to the financial office. He inches toward the door to leave but then turns around, sheepish and tentative.

"Uh, G . . . uh, did you see me . . . right now . . . you know . . . smelling Mario?"

I admit that I had.

"Damn," Frankie huffs and puffs, **"I mean, it's just that . . . well . . . he be smellin' GOOOOD**. I mean . . . all the homies . . . we be likin' his cologne." Breathe it in, breathe it out. The Lord is everything I want. A *yes* that means yes. You want to be there when the poetry happens. Isaiah has God say: "Be glad forever and rejoice in what I create . . . for I create my people to be a delight." God thinking we'd enjoy ourselves. Delighting is what occupies God, and God's hope is that we join in. That God's joy may be in us, and this joy may be complete. We just happen to be God's joy. That takes some getting used to.

"[So] that, with the eyes of your heart enlightened, **you may know what is the** hope to which he has called you."

—Ephesians 1:18

5-9

MAY THE LORD BE WITH YOU

I take Israel and Tony with me to Christ the King parish in Los Angeles. I'm going to speak after the parish spaghetti feed and my two associates will try to sell out all the Homeboy/Homegirl merchandise we've packed in our trunk. But first, they have to sit through the 5:30 p.m. Saturday Mass, with me presiding. On the way home that night, Tony, singularly impressed at Israel's breadth of liturgical knowledge, regales me. Apparently, Israel had absolutely nailed all the responses.

"May the Lord be with you."

"And also with you," Israel confidently returns.

"Lift up your hearts."

"We lift them up to the Lord." No beat gets missed in Israel's comeback. Tony stares at him, amazed. This goes on for the duration of the Mass, and Tony keeps turning and marveling at Israel's adroit certainty in this back and forth of liturgical protocol.

"Let us proclaim the mystery of faith."

And Israel, blindfolded and hands tied behind his back, returns the volley.

"Christ has died. Christ is risen. Christ will come again." That does it. Tony can't take it anymore.

"Hey," he says, tilting toward Israel and whispering, "how you know all this?"

"Juvenile Hall, fool."

If only Tony had been detained on as many cases as Israel, he, too, would be churchgoer of the year.

As we bask in God's attention, our eyes adjust to the light and we begin to see as God does. Then, quite unexpectedly, we discover what Mary Oliver calls **"the music with nothing playing."**

It is an essential tenet of Buddhism that we can begin to change the world by first changing how we look at the world. The Vatican II Council Fathers simply decided to change the opening words of their groundbreaking encyclical, "Gaudium et Spes." Originally, it read, speaking of the world: "The grief and the anguish . . ." Then they just decided to cross out those words and famously inserted instead, "The joy and the hope . . ." No new data had rushed in on them, and the world hadn't changed suddenly. They just chose, in a heartbeat, to see the world differently. They hadn't embraced, all of a sudden, Pollyannaism.

They had just put on a whole new set of eyewear.

"FOR IN HOPE WE WERE SAVED."

—ROMANS 8:24

61

TAKEOFF

I hired [Rickie and Adam] shortly after their brother was killed, and they worked in our Homeboy Merchandising division, selling T-shirts, mugs, mouse pads, and a variety of items sporting the Homeboy logo. They worked closely with enemies—even those who belonged to the gang surely responsible for their brother's death.

A speaking gig in San Francisco came up, and I invited them both—thinking a change of scenery would restore them. They were very excited but completely confounded to discover (once we were at the airport) that, well, we were going to fly and not drive. I guess I thought I had made this clear. Seeing their panic, I decide not to calm them down. Instead, I stop under the wing of the Southwest Airlines plane (at Burbank Airport you walk the tarmac and climb the steps) and stare up, with consternation. "Uh-oh," I say as they rush to my side in a breathless "What?" "What?" unison. I point. "I don't know—is that a crack in the wing, or am I seeing things?" It takes them a while to see what I'm doing, and then they say in brotherly chorus, "You ain't right," "Damn, don't be doing that."

...

Takeoff (as is always the case with novice homie flyers) transforms these two big gangsters into old ladies on a roller coaster. As usual, there is great sighing and clutching and rapid signs of the cross. Adam and Ricky can't take their eyes off the tiny window to their right and manage plenty of "Oh, my God's" and "This is proper." Terror melting into wonder, then slipping into peace. The peanuts and sodas are delivered, and they feel special (they later report to those back

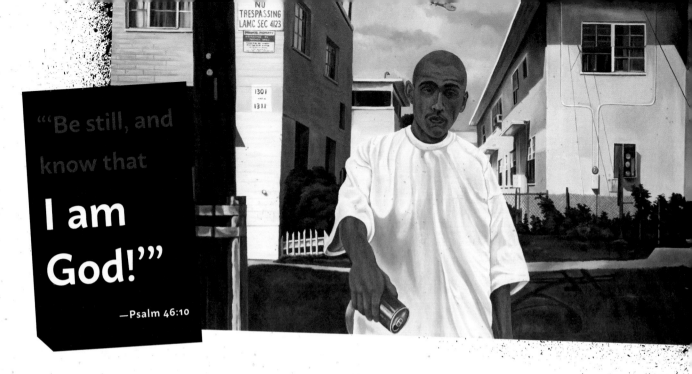

at the office, "They EVEN gave us peanuts!"). Then, after we climb above the bounce, Ricky pats Adam's chest, as they both look out above their own clouds, and whispers, "I love doing this with you, brother."

Life, after unspeakable loss, becoming poetry again. In this together, two brothers, locked arms, delighting in the view from up here.

Thomas Merton writes, "No despair of ours can alter the reality of things, or stain the joy of the cosmic dance which is always there . . . We are invited to forget ourselves on purpose, cast our awful solemnity to the winds and join in the general dance." The cosmic dance is simply always happening, and you'll want to be there when it happens. For it is there in the birth of your first child, in roundhouse bagging, in watching your crew eat, in an owl's surprising appearance, and in a "digested" frog. Rascally inventions of holiness abounding—today, awaiting the attention of our delight. Yes, yes, yes. God so loved the world that He thought we'd find the poetry in it. Music. Nothing playing.

BELOVED

God can get tiny if we're not careful. I'm certain we all have an image of God that becomes the touchstone, the controlling principle, to which we return when we stray.

My touchstone image of God comes by way of my friend and spiritual director, Bill Cain, S.J. Years ago he took a break from his own ministry to care for his father as he died of cancer. His father had become a frail man, dependent on Bill to do everything for him. Though he was physically not what he had been, and the disease was wasting him away, his mind remained alert and lively. In the role reversal common to adult children who care for their dying parents, Bill would put his father to bed and then read him to sleep, exactly as his father had done for him in childhood. Bill would read from some novel, and his father would lie there, staring at his son, smiling. Bill was exhausted from the day's care and work and would plead with his dad, "Look, here's the idea. I read to you, you fall asleep." Bill's father would impishly apologize and dutifully close his eyes. But this wouldn't last long. Soon enough, Bill's father would pop one eye open and smile at his son. Bill would catch him and whine, "Now, come on." The father would, again, oblige, until he couldn't anymore, and the other eye would open to catch a glimpse of his son.

This went on and on, and after his father's death, Bill knew that this evening ritual was really a story of a father who just couldn't take his eyes off his kid. How much more so God? Anthony De Mello writes, "Behold the One beholding you, and smiling."

God would seem to be too occupied in being unable to take Her eyes off of us to spend any time raising an eyebrow in disapproval. What's true of Jesus is true for us, and so this voice breaks through the clouds and comes straight at us. **"You are my Beloved, in whom I am wonderfully pleased." There is not much "tiny" in that.**

"For your steadfast love is greater than the heavens; and your faithfulness reaches to the clouds."

—Psalm 108:4

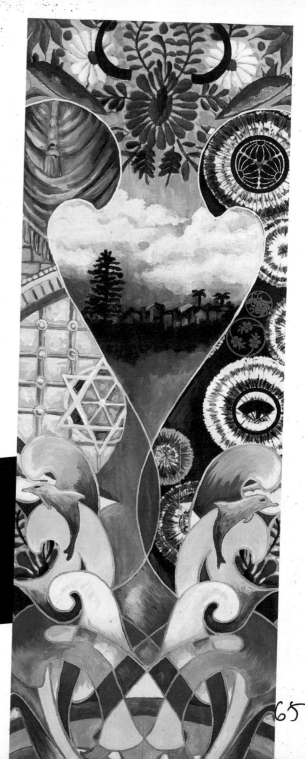

65

THE PREGNANT HEART

Sr. Elaine Roulette, the founder of My Mother's House in New York, was asked, "How do you work with the poor?" She answered, "You don't. You share your life with the poor." It's as basic as crying together. It is about "casting your lot" before it ever becomes about "changing their lot."

Success and failure ultimately have little to do with living the gospel. Jesus just stood with the outcasts until they were welcomed or until he was crucified—whichever came first.

The American poet Jack Gilbert writes, "The pregnant heart is driven to hopes that are the wrong size for this world." The strategy and stance of Jesus was consistent in that it was always out of step with the world. Jesus defied all the categories upon which the world insisted: good-evil, success-failure, pure-impure. Surely, He was an equal-opportunity "pisser off-er" in this regard. The right wing would stare at Him and question where He chose to stand. They hated that He aligned Himself with the unclean, those outside—those folks you ought neither to touch nor to be near. He hobnobbed with the leper, shared table fellowship with the sinner, and rendered Himself ritually impure in the process. They found it offensive that, to boot, Jesus had no regard for their wedge issues, their constitutional amendments, or their culture wars.

The Left was equally annoyed. They wanted to see the ten-point plan, the revolution in high gear, the toppling of sinful social structures. They were impatient with His brand of solidarity. They wanted to see Him taking the right stand on issues, not just standing in the right place.

But Jesus just stood with the outcast. The Left screamed: "Don't just stand there, do something." And the Right maintained: "Don't stand with those folks at all." Both sides, seeing Jesus as the

66

wrong size for this world, came to their own reasons for wanting Him dead. Both sides were equally impressed as He unrolled the scroll and spoke of "good news to the poor" . . . "sight to the blind" . . . "liberty to captives." Yet only a handful of verses later, they want to throw Jesus over a cliff.

How do we get the world to change anyway? Dorothy Day asked critically: "Where were the saints to try and change the social order? Not just minister to the slaves, but to do away with slavery." Dorothy Day is a hero of mine, but I disagree with her here. You actually abolish slavery by accompanying the slave. We don't strategize our way out of slavery: we solidarize, if you will, our way toward its demise. We stand in solidarity with the slave, and by so doing, we diminish slavery's ability to stand. By casting our lot with the gang member, we hasten the demise of demonizing. All Jesus asks is, *"Where are you standing?"* And after chilling defeat and soul-numbing failure, He asks again, "Are you still standing there?"

Can we stay faithful and persistent in our fidelity even when things seem not to succeed? I suppose Jesus could have chosen a strategy that worked better (evidenced-based outcomes)—that didn't end in the Cross—but he couldn't find a strategy more soaked with fidelity than the one he embraced.

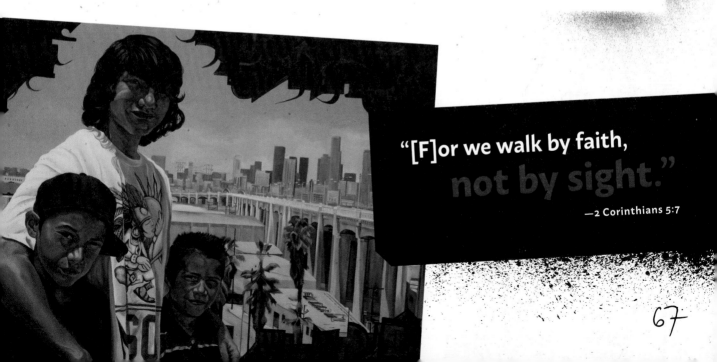

"[F]or we walk by faith, not by sight."

—2 Corinthians 5:7

67

KINSHIP

No daylight to separate us.

Only kinship. Inching ourselves closer to creating a community of kinship such that God might recognize it. Soon we imagine, with God, this circle of compassion. Then we imagine no one standing outside of that circle, moving ourselves closer to the margins so that the margins themselves will be erased. We stand there with those whose dignity has been denied. We locate ourselves with the poor and the powerless and the voiceless. At the edges, we join the easily despised and the readily left out. We stand with the demonized so that the demonizing will stop. We situate ourselves right next to the disposable so that the day will come when we stop throwing people away. The prophet Habakkuk writes, "The vision still has its time, presses on to fulfillment and it will not disappoint . . . and if it delays, wait for it."

Kinship is what God presses us on to, always hopeful that its time has come.

> "'Blessed are the peacemakers,
> **for they will be called children of God.'"**
>
> —Matthew 5:9

KINSHIP PART II

Mother Teresa diagnosed the world's ills in this way: We've just "forgotten that we belong to each other." Kinship is what happens to us when we refuse to let that happen. With kinship as the goal, other essential things fall into place; without it, no justice, no peace. I suspect that were kinship our goal, we would no longer be promoting justice—we would be celebrating it.

Kinship has a way of sneaking up on you even as you seek to create it. I celebrate Catholic services, on a rotating basis, in twenty-five detention institutions in Los Angeles County—juvenile halls, probation camps, jails, and state Youth Authority facilities. After Mass, in the gym or chapel or classroom, I hand out my card. The infomercial is always the same:

"Call me when you get out. I'll hook you up with a job— take off your tattoos—line ya up with a counselor. I won't know where you are, but with this card, you'll know where I am. Don't slow drag. Cuz if you do, you'll get popped again and end up right back here. So call me." I hand out thousands of cards a year.

A homie named Louie, seventeen years old, appears in my office one day, bright, happy, and smiling. Never in my life had I seen more hickeys on a human being than on this guy. His entire neck is spotted with these *chupetonazos*. Even his cheeks are covered. I'm thinking Mr. Guinness of the world records might be interested in talking to Louie.

"So, here I am," he says, arms outstretched, "I just got out yesterday," and he points at me with glee, "and YOU . . . are the VERY FIRST person I came to see."

I look at this giddy gang member and say, "Louie . . .
I have a feeling I was your second stop."

The two of us collapse in laughter and, suddenly, there's kinship so quickly. Not service provider and service recipient. No daylight to separate—just "us."

Exactly what God had in mind.

Often, we strike the high moral distance that separates "us" from "them," and yet it is God's dream come true when we recognize that there exists no daylight between us. Serving others is good. It's a start. But it's just the hallway that leads to the Grand Ballroom.

Kinship—not serving the other but being one with the other. Jesus was not "a man for others"; he was one with them. There is a world of difference in that.

"**As God's chosen ones,** holy and beloved,
clothe yourselves with compassion, kindness, humility, meekness, and patience.
Bear with one another and, if anyone has a complaint against another, forgive each other;
just as the Lord has forgiven you, so you also must forgive."

—Colossians 3:12-13

ENOUGH

"When we cry, 'Abba! Father!'
it is that very Spirit bearing witness with our spirit that we are
children of God, and if children, then heirs, heirs of God and joint heirs with Christ."

—Romans 8:15-17

72

One day, I have three homies in my car as I am headed to give a talk. While there, they will set up a table and sell Homeboy/Homegirl merchandise. Our banter in the car spans the range of bagging on each other. We laugh a lot, and I am distracted enough not to notice that the gas tank is on empty. I lean into JoJo, the homie occupying shotgun.

"*Oye*, dog, be on the lookout for a gas station."

He doesn't seem to wholly trust my judgment. He leans toward the gas gauge and dismisses my call.

"You're fine," he says.

"*Cómo que* I'm fine—I'm on *ÉCHALE, cabrón.*" Waving at him, I say, "HELLO, E means empty."

JoJo looks at me with bonafide shock. "E means empty?"

"Well, yeah, what did ya think it meant?"

"Enough."

"Well, what did ya think F stood for?"

"Finished."

After I thank him for visiting our planet, I realize that this is exactly how the dismantling process has to play itself out. Homies stare into the mirror and pronounce "EMPTY." Our collective task is to suggest instead "ENOUGH"—enough gifts, enough talent, enough goodness. **When you have enough, there's plenty.**

Or if their verdict is "FINISHED," we are asked to lead them instead to "fullness"—the place within—where they find in themselves exactly what God had in mind. It would be hard to overstate how daunting it is to conjure new images and reconstruct messages.

73

THE SOUL FEELS ITS WORTH

Fifteen years ago, Bandit came to see me. He had been well named by his homies, being at home in all things illegal. He was "down for his varrio" and put in time running up to cars and selling crack in Aliso Village. He spent a lot of time locked up and had always seemed impervious to help. But then that day, fifteen years ago, his resistance broke. He sat in my office and said he was "tired of being tired." I escorted him to one of our four job developers, and, as luck would have it, they located an entry-level job in a warehouse. Unskilled, low-paying, a first job.

Cut to fifteen years later, Bandit calls me near closing time on Friday. He now runs the warehouse, owns his own home, is married with three kids. I hadn't heard from him in some time. No news is usually good news with homies. **He speaks in something like a breathless panic.**

"G, ya gotta bless my daughter."

"Is she okay?" I ask. "I mean, is she sick—or in the hospital?"

"No, no," he says, "on Sunday, she's goin' to Humboldt College. Imagine, my oldest, my Carolina, goin' to college. But she's a little *chaparrita*, and I'm scared for her. So, do ya think you could give her a little send-off *bendición?*

I schedule them to come the next day to Dolores Mission, where I have baptisms at one o'clock. Bandit, his wife, and three kids, including the college-bound Carolina, arrive at 12:30. I situate them all in front of the altar, Carolina planted in the middle. We encircle her, and I guide them to place their hands on her head or shoulder, to touch her as we close our eyes and bow our

heads. **Then, as the homies would say, I do a "long-ass prayer,"** and before we know it, we all become *chillones*, sniffling our way through this thing.

I'm not entirely sure why we're all crying, except, I suppose, for the fact that Bandit and his wife don't know anybody who's gone to college—except, I guess, me. Certainly no one in either one of their families. So, we end the prayer, and we laugh at how mushy we all just got. Wiping our tears, I turn to Carolina and ask, "So, what are ya gonna study at Humboldt?"

She says without missing a beat,

"Forensic psychology."

"Daaamn, forensic psychology?"

Bandit chimes in, "Yeah, she wants to study the criminal mind."

Silence.

Carolina turns slowly to Bandit, holds up one hand, and points to her dad, her pointing finger blocked by her other hand so he won't notice. We all notice and howl and Bandit says, "Yeah, I'm gonna be her first subject!"

We laugh and walk to the car. Everyone piles in, but Bandit hangs back. "Can I tell you something, dog?" I ask, standing in the parking lot. "I give you credit for the man you've chosen to become. I'm proud of you."

"*¿Sabes qué?*" he says, eyes watering, "I'm proud of myself. All my life, people called me a lowlife, a *bueno para nada*. I guess I showed 'em."

I guess he did.

And the soul feels its worth.

> "**For we are what he has made us,** created in Christ Jesus for good works, which God prepared beforehand to be our way of life."
>
> —Ephesians 2:10

BE FAITHFUL

People want me to tell them success stories. I understand this. They are the stories you want to tell, after all. So why does my scalp tighten whenever I am asked this? Surely, part of it comes from my being utterly convinced I'm a fraud.

I find Bill Cain's reflection on the Shroud of Turin very consoling. He prefers frauds. He says, "If the shroud is a fraud, then it is this masterful work of art. If it's the real thing, it's just dirty laundry."

Twenty years of this work has taught me that God has greater comfort with inverting categories than I do. What is success and what is failure? What is good and what is bad? Setback or progress? Great stock these days, especially in nonprofits (and who can blame them), is placed in evidence-based outcomes. People, funders in particular, want to know if what you do "works."

Are you, in the end, successful? Naturally, I find myself heartened by Mother Teresa's take: **"We are not called to be successful, but faithful."** This distinction is helpful for me as I barricade myself against the daily dread of setback. You need protection from the ebb and flow of three steps forward, five steps backward. You trip over disappointment and recalcitrance every day, and it all becomes a muddle. God intends it to be, I think. For once you choose to hang out with folks who carry more burden than they can bear, all bets seem to be off. **Salivating for success keeps you from being faithful,** keeps you from truly seeing whoever's sitting in front of you. Embracing a strategy and an approach you can believe in is sometimes the best you can do on any given day. If you surrender your need for results and outcomes, success becomes God's business. I find it hard enough to just be faithful.

> "Trust in the LORD with all your heart,
> and do not rely on your own insight.
> In all your ways acknowledge him,
> and he will make straight your paths."
>
> —Proverbs 3:5-6

76

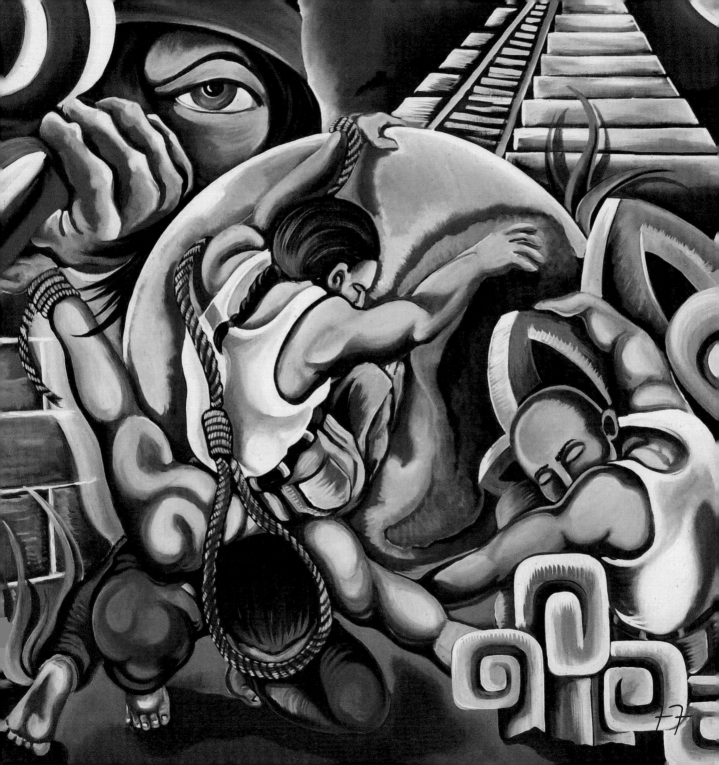

OPENING
FISTS

I've learned from giving thousands of talks that you never appeal to the conscience of your audience but, rather, introduce them to their own goodness. I remember, in my earliest days, that I used to be so angry. In talks, in op-ed pieces, in radio interviews, I shook my fist a lot. My speeches would rail against indifference and how the young men and women I buried seemed to matter less in the world than other lives. I eventually learned that shaking one's fist at something doesn't change it. Only love gets fists to open. **Only love leads to a conjuring of kinship within reach of the actual lives we live.**

"Hatred stirs up strife,
but love covers all offenses."
—Proverbs 10:12

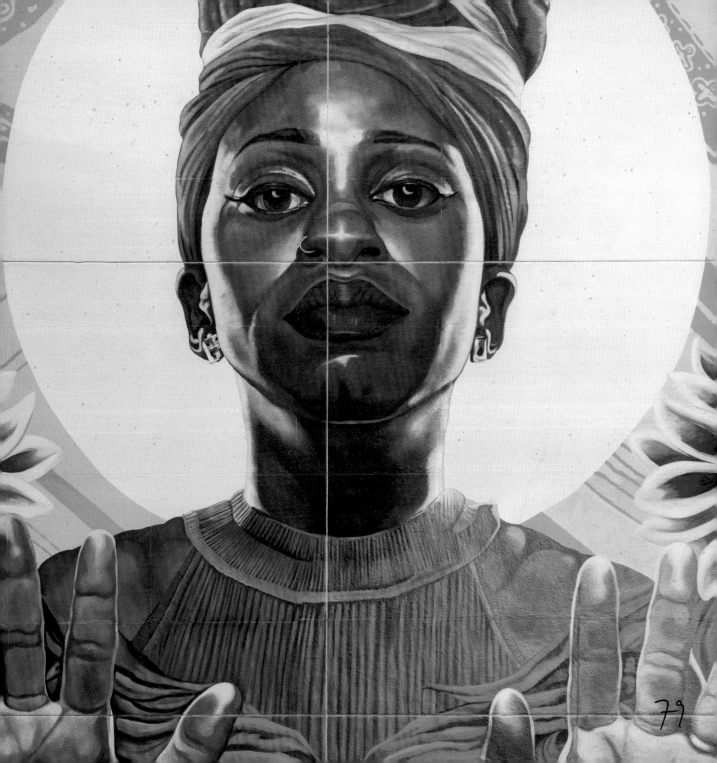

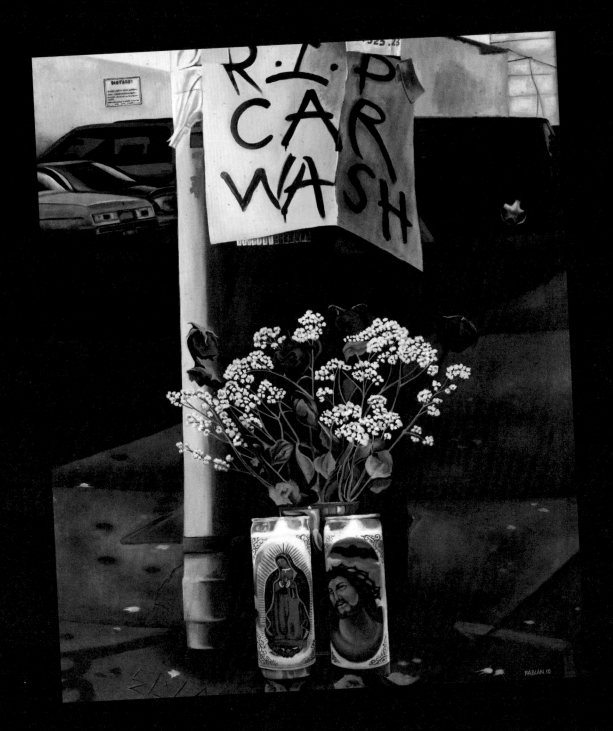

80

CIRCLE

At Homeboy Industries, thousands and thousands of rival gang members—men and women—have worked in our nine social enterprises: Homeboy Bakery, Homeboy Silkscreen and Embroidery, Homeboy/Homegirl Merchandising, Homeboy Diner (the only place to buy food in the Los Angeles City Hall), Homeboy Café at Los Angeles International Airport, Homeboy Farmers Markets, Homeboy Grocery (a line of food products), Homeboy Recycling, and Homegirl Café and Catering. I'd like to think that if Jesus had more time on this earth, he might well have explored the entrepreneurial. Maybe a clothing line: the Leper Colony, or the Tax Collector's Café, or the Ritually Impure Maintenance Crew. Beyond cure and healing, Jesus was always hopeful about widening the circle of compassion and dismantling the barriers that exclude. He stood with the sinner, the leper, and the ritually impure to usher in some new remarkable inclusion, the very kinship of God. Living the gospel, then, is less about **"thinking outside the box"** than about choosing to live in this ever-widening circle of inclusion.

> "There is no longer Jew or Greek, there is no longer slave or free, there is no longer male and female; for all of you are one in Christ Jesus."
>
> —Galatians 3:28

ÁNDALE!

I was once saying Mass at the San Fernando Juvenile Hall. With nearly three hundred detained minors—mostly gang members—a homie reads from Psalm 138. I'm seated, vested, eyes closed, choosing to listen to this kid's proclamation rather than follow along in the liturgical sheet that rests on my lap. He reads, with an overabundance of confidence, **"The Lord . . . is EXHAUSTED."** *What the hell?* I open my eyes and hurriedly refer to my sheet. It says "The Lord is exalted," but I think "exhausted" is way better. I'm not sure I want to spend eternity with a God who wants to be exalted, who longs to be recognized and made a big deal of. I would rather hope for a humble God who gets exhausted in delighting over and loving us. That is a better God than the one we have.

All of us have had conversations with friends in which we ask how they're doing and they respond, "I'm so tired. But it's a good tired." Then they will tell you how they spent the day helping a friend move into her apartment or the weekend watching their grandkids. It's a "good" tired because it was spent in extension to another. The exhausted God is always greater than the exalted one.

One day a homie comes into my office with his five-year-old son. "He's got a question for ya." The kid looks at me and sidles closer, nervous but determined.

"The God who made the world and everything in it, he who is Lord of heaven and earth, does not live in shrines made by human hands."

—Acts of the Apostles 17:24

"Does God have hair, and does he wear a robe?"

I look him in the eye. "Yes, and only when he steps out of the shower."

God, of course, is unchanging and immutable. But our sense of who God is changes as we grow and experience God, and God is constantly nudging us toward that evolution. It is true enough that my image of God at five years old is not the one I have today. And if that's true, why wouldn't my sense of God be different ten minutes from now and twenty minutes after that?

God leans into us so that we will let go of the image of God as unreasonable parent, exacting teacher, or ruthless coach. God is not who we think God is. Our search for God is not a scavenger hunt; God is everywhere and in everything. Our sense of God always beckons us to grow, to reimagine something wildly more breathtaking than where our imagination generally takes us. We are nudged toward an increasingly wider view and image of God from our child consciousness to an adult consciousness. God leans into us so that we can find our way to this inner absorption of God. With any luck and some attention, we will keep landing on a better God, finally having grown comfortable in God's tenderness. Our God is constantly saying, "*Ándale*" . . . "Go ahead."

We refine our sense, then, of God and what Ignatius calls the "Magis," which refers to an affection for God. He also calls it "devotion," which is a pervasive familiarity and union with God, a desire to want what God wants. We seek to live where God is, and our understanding of that evolves and changes all the time. This is consequential, for, as Jesus says, "Come to me and you'll find rest." We are not being offered sleep, but freedom. **There is an openness—the spacious, expansive, inclusive heart to which we are invited.** **"*Ándale*."**

83

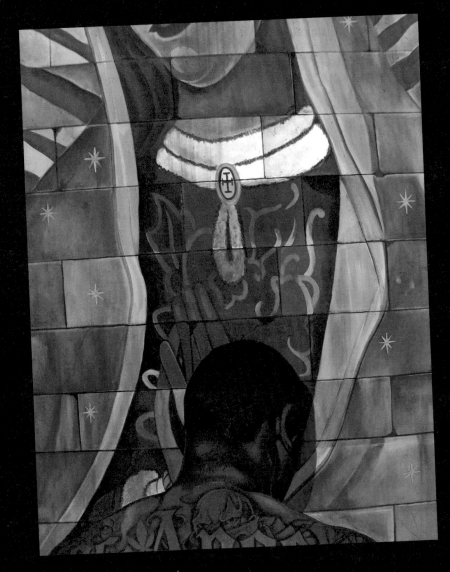

"Create in me a clean heart, O God, and put a new and right spirit within me."

—Psalm 51:10

KNUCKLEHEAD

"Working on yourself" doesn't move the dial on God's love. After all, that is already fixed at its highest setting. But the work one does seeks to align our lives with God's longing for us—that we be happy, joyful, and liberated from all that prevents us from seeing ourselves as God does.

I'm in my office talking to a homie, a senior staff member, when I catch a glimpse of Froggy in the reception area. Froggy is a seventeen-year-old who had worked for us for a time but was sent to a "suitable placement"—in his case, a group home—for a year after violating his probation. I wave to him and share my excitement with the homie seated there that he's been granted a pass to visit.

"Pass, my ass," the homie says and sighs. "He AWOL'd."

Immediately, I tell him to Bring Me the Head of Froggy. I prepare myself for a pointed conversation, in which I'll underscore that AWOLing is a big mistake but that it can be corrected if he lets me drive him back to the group home before his Great Escape lands him on *America's Most Wanted*.

Froggy walks in. Or, rather, slinks in, shoulders slumped, no hug or greeting, like Charlie Brown after his kite gets stuck in a tree.

"Froggy, my son," I tell him, "I have three words for you," preparing to hand him a piece of paper on which I've written the word "mistake" three times. But he waves me off.

"I already be knowin' what the three words are," he says. I ask him, intrigued. Using his fingers to count them off, he recites, **"Knuck . . . El . . . Head."**

"All right," I tell him, "your three beat mine," and I throw my piece of paper away.

Some days, the best you can hope for is to plant yourself in the surety of a love that won't budge in the face of a knucklehead mistake.

THE GRATEFUL HEART

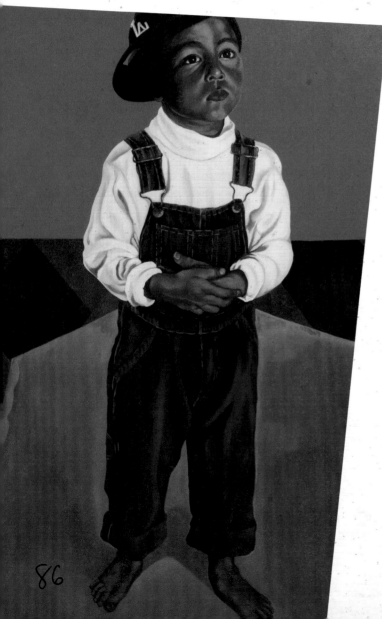

I run into Joey at a Target. He's pushing a shopping cart and his two young boys are clinging to the sides, enjoying the ride, limber as two marsupials. We are happy to have this "aisle five" encounter. It's been a while. When he first came to us, Joey had been living in the heart of his enemy's neighborhood, fearful for his life and the constant pull of his homies. He became a trainee at Homeboy, and after eighteen months the job developers located a good-paying job for him in a warehouse. In the time since, he moved to a place where he could breathe easier. "That last place I lived," he says to me, "I'd be singin' the *Mission Impossible* theme song to myself as I ran to the bus stop. Now where I live, it's *calmado*. I be singin' *'It's a beautiful day in the neighborhood.'*"

Chance meetings like this in a Target give me an opportunity to take a homie's temperature, to gauge his commitment to his new life. I ask if he's heard from anyone from his "neighborhood" (his gang).

He shakes his head with something of a scowl and says no. "I don't go to the barrio. Don't hear from anyone anymore." Then something sparks a memory. "Well, wait . . . I did get a call a couple months ago from a youngster from the neighborhood. Don't know how he got my number. He called to say there was gonna be a meeting."

Gangs will, on occasion, meet in a park or any large venue to accommodate a hefty number of folks. Attendance is mandatory.

I asked how he responded. "I said, 'I'm not goin' to your meeting. I'm a man. I have a job. I'm a husband and a father. I'm not goin' to yer damn meeting." His tone in the telling is rock solid, and he even scoffs a little. I'm impressed. I ask what the response was. Joey shrugs with amusement. "He called me a punk." In gang parlance, that's a tough word to be on the receiving end of. "I told him if I was a punk," Joey chuckles as he continues, "I'd be goin' to your meeting." As they say on game shows: **"Good answer!"**

The hope, always, is that homies won't settle for just answers but instead hold out for meaning. The goal is not perfection but a wholeness anchored in grateful living, in knowing what you have. Joey discovered that once you try wanting what you have, everything changes. **The Peruvian priest Gustavo Gutiérrez believed that only one kind of person transforms the world: the one with the grateful heart.**

"Rejoice always, pray without ceasing, give thanks in all circumstances; for this is the will of God in Christ Jesus for you."

—1 Thessalonians 5:16-18

THE NOTE

I'll admit, there are some homies you look at and think to yourself, *Yeah, I'm not so sure this guy will ever be able to turn the ship around.* You don't admit this to anyone, though. You keep it to yourself and hope that everyone—anyone—can alter course. People always surprise you.

Johnny was such a kid. I met him when he was fifteen, but never in my office. He never wanted to be seen there. I'd catch him in the alley where his homies would gather; he was way tougher than someone his age ought to be. He had certainly "put in work" for his neighborhood, stuff that eventually landed him in juvenile hall, then probation camp, then Youth Authority, and finally prison. He walked out of there at twenty years old yet still refused to set foot into Homeboy.

But it takes what it takes. Johnny found himself tending to his mother, who was struck with pancreatic cancer. In the last six months of her life, I'd visit and watch how tenderly Johnny would attend to her every need, becoming the hospice point person and caring for her with such affection. When she died, I buried her. A week later Johnny walked into Homeboy Industries.

Four months into his stay with us as a trainee, he wanders into my office to talk. "What happened to me yesterday," he begins, "has never happened to me in my life." He tells me that he was riding the LA Metro Gold Line train, which he caught at the Chinatown station, heading east after his day's work. The car he was in was packed, yet he managed to secure a seat for himself. Standing in front of him, hanging on to the pole, was a gang member, a little older than Johnny, but with tattoos and *medio pedo* (a little bit drunk). Johnny was wearing a Homeboy T-shirt with the insignia and slogan **"Jobs Not Jails"** quite large over his chest. The homie, still a little wobbly, looked closely at the shirt, then at Johnny.

"You work there?" he asked.

Johnny, initially hesitant to engage the guy, nodded.

"It any good?" the guy fired back—not belligerent, just persistent.

Johnny shrugged. "Well, it's helped me. I don't think I'll ever go back to prison because of this place," tapping the front of his shirt as he said it. Then Johnny stood, feeling as the prophet Ezekiel did when he wrote that "the Spirit set me on my feet." He fished a clean piece of paper from his pocket and located a pen from another. He wrote down the Homeboy address. He tells me, "I couldn't believe I knew it by heart."

Johnny handed the note to the man. "Come see us," he said. "We'll help you."

The guy hanging on the pole studied the piece of paper. "Thank you," he quietly replied. The train arrived at its next stop, and the guy got off. Johnny reclaimed his seat and looked around the train.

"What happens next," he tells me, "has never happened to me in my whole life. Everyone on the train was lookin' at me. Everyone on the train was noddin' at me. Everyone on the train was smilin' at me." His lip trembles and a tear escapes. **"And for the first time in my life . . . I felt admired."**

There is a Chinese proverb, "The beginning of wisdom is to call things by their right name." We want to find the right name for what was done to us, for what turned us around, for what is happening to us now. We all want to find our maximum capacity. And when that desire is strong enough, we find the legs to walk us through the hallway, down the path, on the Good Journey.

The walking back is the arriving.

"I will lead the blind by a road they do not know,
by paths they have not known I will guide them.
I will turn the darkness before them into light, the rough places into level ground.
These are the things I will do, and I will not forsake them."

—Isaiah 42:16

89

DON'T LEAVE ANYONE BEHIND

In John's gospel, Jesus says farewell and consoles us with "I will not leave you as orphans." "Orphan" is a word packed with meaning and significance, especially at Homeboy Industries, where virtually everyone there is one. Surely, the word finds much of its charge from the earliest biblical agreement between God and God's people. For this reason, like most utterances of Jesus in the Gospel, "I will not leave you as orphans" is not just supposed to fill us with consolation but is to be received as an invitation. It seems to say, *As I won't leave you an orphan, don't you leave anyone behind.* We are meant to hear in these words a call to seek out the isolated, the rejected, the abandoned. Then we are meant to walk toward them, with open arms, **and bring them in to the place of belonging.**

"I AM WITH YOU ALWAYS."

—MATTHEW 28:20

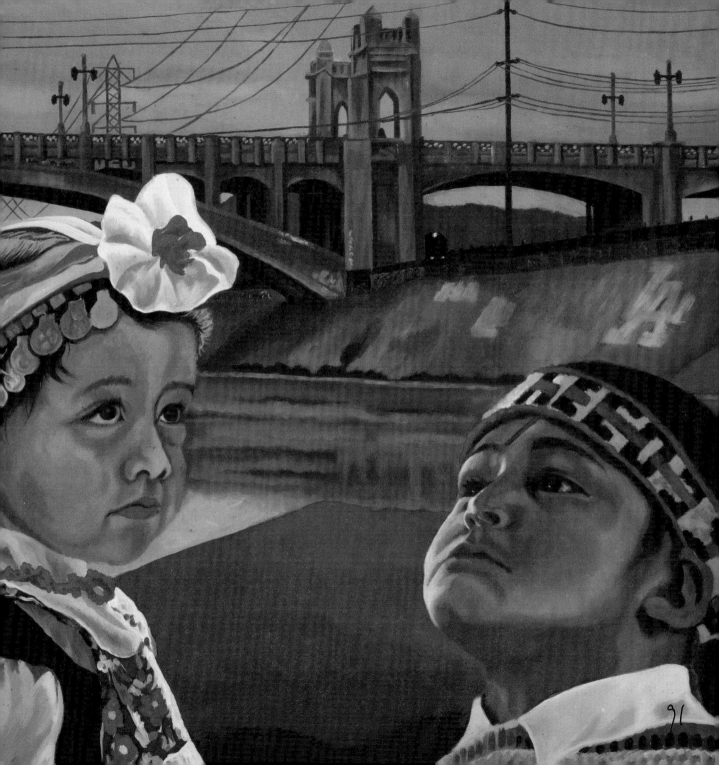

HOPE DOES NOT DISAPPOINT

Our quest for kinship is fueled by the engine of hope. As the great Shirley Torres, director of reentry services for Homeboy Industries, told our staff during our financial crisis: "If we lose hope, there's no hope to give them." Through hope, we gain the unshakable belief that our lives are workable. It is only together that we can realize our hearts are resilient things, able to hold inexhaustible freedom and compassion.

Horacio, a young homie at a Youth Authority facility, is about to be released and is frightened. He's been close to leaving before, but then he gets into a fight or starts a brawl that derails his plans. He did this once during a Mass of mine there. Communion time arrived, and suddenly he was flying through the air, *Matrix*-like, pummeling every enemy in line to receive communion. The supervising staff took out their pepper spray, covering us all in a cloud of gas. It is the only time I've ever been pepper sprayed. We were all down on the ground, trying to stay below the fumes, when I turned to the homie next to me and asked if he thought Mass was over.

"Trust me," he says, chuckling. "Mass is over."

I took a leave from Mass duties at the facility while going through chemo, and when I returned, the guys presented me with a shadow box containing a photo of the homies—and the spent pepper spray canister. It is a cherished possession of mine. Horacio also stood up and publicly apologized for starting the riot that had taken place months before. Then he asked to speak with me. He was terrified of leaving the only place he'd known as home.

"What are you afraid of?" I asked him when we were alone.

After a long silence, he looked at me. "I'm afraid I'll forget my hope."

"Hope does not disappoint," Saint Paul tells us. This is always a challenge with gang members—who, more often than not, don't think their own death is a waste but think that their lives are.

"I'm messin' up in school," a young homie tells me. When I ask him why, he says without hesitation: "I know why. I don't have a dream. Ya gotta have a dream, something to look forward to." Hope is not about some assurance that everything will work out but rather about a confidence that purpose and luminous meaning can be found there, no matter how things unfold. "The self-fulfilling prophecy of the nihilistic threat," Cornel West writes, "is that without hope there can be no future, **that without meaning, there can be no struggle."**

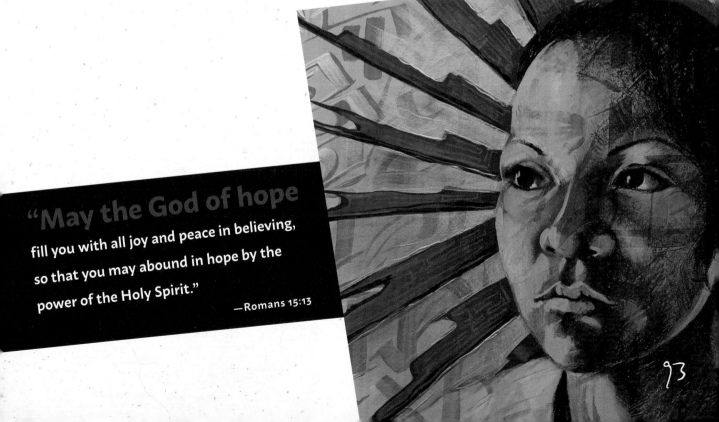

"May the God of hope fill you with all joy and peace in believing, so that you may abound in hope by the power of the Holy Spirit."
—Romans 15:13

THE ORIGINAL PROGRAM

There are two hundred references in Scripture that ask us to take special care of the poor. I'm guessing, then, it's important. It is this preferential care and love for the poor that sets the stage for the original program. It doesn't draw lines—it erases them. It rises above the polarizing temperature of our times. It doesn't shake its finger at anybody but instead helps us all put our finger on it. We could ask ourselves, I suppose, if God is conservative or liberal, but I think that's the wrong question. Instead, we should ask: Is God expansive or tiny? Is God spacious or shallow? Is God inclusive or exclusive? What are the chances that God holds the same tiny point of view as I do? Well, zero. The Choir aims to challenge the politics of fear and the stances that limit our sense of God. It believes that a love-driven set of priorities will ignite our own goodness and reveal our innate nobility, which God so longs to show us. It invites us to inch the world closer to what God might have had in mind for it. And the poor are our trustworthy guides in this.

The original covenantal relationship in the Hebrew Bible (the *original* program) went like this: "As I have loved you, so must you have a special, preferential, favored love for the widow, orphan, and stranger." God knows that these folks know what it's like to be cut off. And because they know this particular suffering, God finds them trustworthy to lead and guide the rest of us to the birth of a new inclusion, to the exquisite mutuality of kinship:

God's dream come true.

94

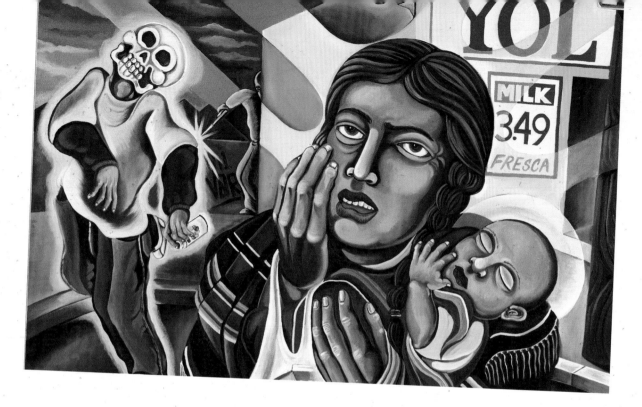

When the gospel connects with our hearts and we find ourselves on the "outskirts," those on the margins may wonder what we're doing there. They aren't accustomed to our presence in their space. In the end, though, the measure of our compassion with what Martin Luther King calls **"the last, the least, and the lost"** lies less in our service to those on the margins and more in our willingness to see ourselves in kinship with them. It speaks of a kinship so mutually rich that even the dividing line of service provider/service recipient is erased. We are sent to the margins NOT to make a difference but so that the folks on the margins will make *us* different.

"[F]or I was hungry and you gave me food, I was thirsty and you gave me something to drink, I was a stranger and you welcomed me."

—Matthew 25:35

95

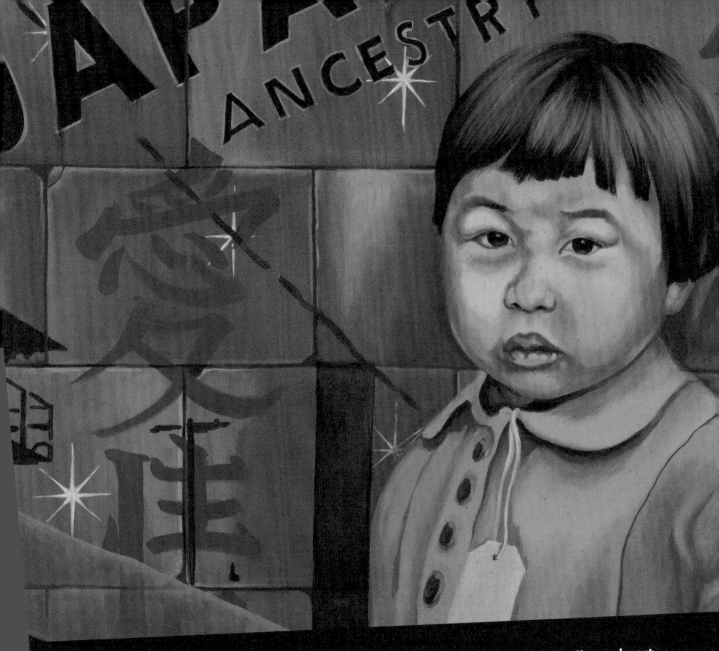

"He said to him, 'You shall love the Lord your God with all your heart, and with all your soul, and with all your mind.'"

THE CENTER

Some people say, "God is good, and God has a plan for you." I believe that God is good but also that God is too busy loving me to have a plan for me. Like a caring parent, God receives our childlike painting of a tree—usually an unrecognizable mess—and delights in it. God doesn't hand it back and say "Come back when it looks more like a tree" or tell us how to improve it. God simply delights in us. Like the kid at probation camp after confession: "You mean you just sealed my record?" The God who always wants to clean the slate is hard to believe. Yet the truth about God is that God is too good to be true. And whenever human beings bump into something too good to be true, we decide it's not true.

In a correspondence with a priest in Ireland, Jackie Kennedy wrote that she felt bitter toward God after the assassination of her husband. "How could God let this happen?" she asked. But God wasn't in the Texas School Book Depository, aiding and abetting. God was—and is—in the heartbreak and in the insight born of sadness, and in the arms that wrap around our grief. I have felt this every time a kid is gunned down. Or when you have to lay off three hundred of your workers because you can't meet payroll. Or when you are given a cancer diagnosis. Such things don't shake your faith—they shape it.

Some things are random and other things are meant to be in our control. So, God is with me when "shit happens" and God is rooting for me when I need to decide things. And I'm okay with that. I don't need God to be in charge of my life. **I only need God to be at the center of it.**

FOR YOU

Often enough, we get in the habit of shaking our fists at God and saying, *WHAT do you WANT from me?* We are programmed this way as humans. But I suppose it would be more accurate to ask God this: *What do you want FOR me?* For starters: life, happiness, and peace: My joy yours. Your joy complete. **That's it. Nothing less than that.**

> **"His divine power has given us everything** needed for life and godliness, through the knowledge of him who called us by his own glory and goodness."
>
> —2 Peter 1:3

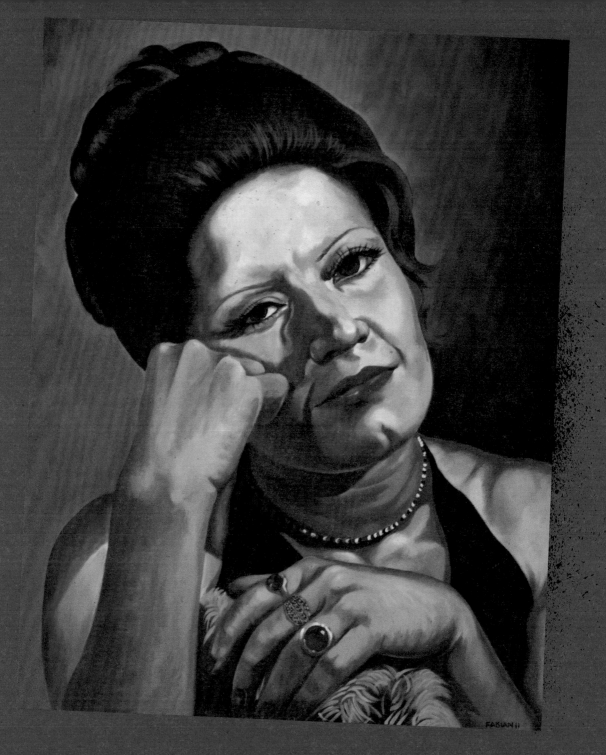

CHICO

At the cemetery, as I bless the gold cross resting on [Chico's] coffin and hand it to Rosa, a thought comes to me. I realize that I really must let this grief in. For too long, I had suspended my own profound sense of loss, dutifully placing it on my own emotional back burner. I needed to be there for Chico's family, his girlfriend, his homies. So, I give myself permission now to allow this pain into some cherished, readied place in my heart. Every homie's death recalls all the previous ones, and they all arrive at once, in a rush. I'm caught off guard, as well, by the sudden realization that Chico's burial is my eighth in the past three weeks.

I decide to walk away from the coffin and spot a lonely tree not too far from the crowd. I stand there by myself and welcome all the feelings of this great loss. I cry. Before too long, the mortician appears at my side. He is more acquaintance than friend.

8

Now he has broken the spell of my grief and unknowingly invaded the space I had carved out for myself. I am overwhelmingly annoyed that he has done so. Then, I'm annoyed that I'm annoyed. There is an obligation, clear and immediate, to break the silence, to welcome the mortician into my space, uninvited though he is. I remove my glasses and wipe away my tears. I point feebly at Chico's coffin and know that I need to find some words to fill our blank air.

"Now that," I whisper to the intruder, **"was a terrific kid."**

And the mortician, in a voice so loud and obnoxious that it turns the heads of all the gathered mourners, says, "HE WAS?"

My heart sinks. I know exactly what he's thinking. *No cabe*—something isn't fitting here; there is some large disconnect for him, and he's incredulous. How could it be possible that a sixteen-year-old *cholo*, gunned down, not far from his home, be a terrific kid?

But who wouldn't be proud to claim Chico as their own?

His soul feeling its worth before its leaving.

The mortician's incredulity reminds me that kinship remains elusive. Its absence asserts that any effort to help someone like Chico just might be a waste of our collective time.

"But in this place of which you say it is a waste, there will be heard again the voice of mirth and the voice of gladness . . . the voices of those who sing."

And so, the voices at the margins get heard and the circle of compassion widens. Souls feeling their worth, refusing to forget that we belong to each other. No bullet can pierce this. The vision still has its time, and, yes, it presses on to fulfillment. It will not disappoint. And yet, if it delays, we can surely wait for it.

> **"'Truly I tell you, today you will be with me in Paradise.'"**
>
> —Luke 23:43

In 1988, Jesuit Priest Gregory Boyle and community leaders started what would eventually become Homeboy Industries. This organization employs and trains former gang members in a range of social enterprises and provides critical services to thousands of men and women who walk through its doors every year seeking a better life.

Gregory Boyle is the author of the 2010 *New York Times* best-seller *Tattoos on the Heart: The Power of Boundless Compassion* (2010), *Barking to the Choir* (2017), and *The Whole Language* (2021). In 2014, the White House named Boyle a Champion of Change, and he received the University of Notre Dame's 2017 Laetare Medal, the oldest honor given to American Catholics.

Fabian Debora was born in El Paso, Texas, and began his career in 1995 as a member of the East Los Angeles Streetscapers. He was mentored by many Chicano artists and muralists. Fabian's work has been showcased in solo and group exhibitions throughout the United States and abroad, including Santa Barbara, Los Angeles, Kansas City, Brooklyn, and throughout Latin America.

105

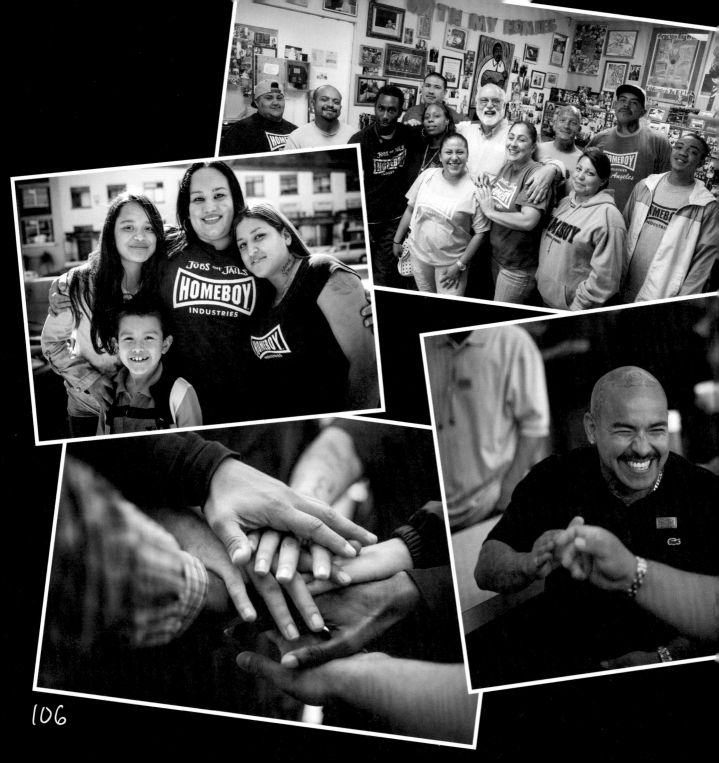

INDUSTRIES

Homeboy Industries is the largest gang rehabilitation and reentry program in the world. For over 30 years, we have stood as a beacon of hope in Los Angeles to provide training and support to formerly gang-involved and previously incarcerated people, allowing them to redirect their lives and become contributing members of our community.

For more information, please visit https://homeboyindustries.org.

107

108

Acknowledgements and Sources

Thank you to David McCormick for his goodwill and support of this project. And thank you to Richard Rhorer, Jofie Ferrari-Adler, and Simon & Schuster for graciously allowing excerpts from *Tattoos on the Heart*, *Barking at the Choir*, and *The Whole Language* to appear in this book. Finally, big thanks to Paul Audia for his photo on p. 102 and Eddie Ruvalcaba whose photos appear on pp. 105–108.

Excerpts on pp. 4–5, 6–7, 8, 11, 13, 14, 17, 18, 20–21, 23, 25, 26, 29, 31, 32, 34–35, 37, 39, 40, and 43 are from *The Whole Language* by Gregory Boyle, copyright © 2021 by Gregory Boyle. All rights reserved. Used with permission of Avid Reader Press, an imprint of Simon & Schuster.

Excerpts on pp. 78, 81, 82–83, 85, 86–87, 88–89, 90, 92–93, 94–95, 97, 98, and 100–101 are from *Barking at the Choir* by Gregory Boyle, copyright © 2017 by Gregory Boyle. All rights reserved. Used with permission of Simon & Schuster.

Excerpts on pp. 2–3, 45, 46, 49, 50, 53, 54, 56–57, 59, 60–61, 62–63, 64–65, 66–67, 69, 70–71, 73, 74, 75, and 76 are from *Tattoos on the Heart* by Gregory Boyle, copyright © 2010 by Gregory Boyle. All rights reserved. Used with permission of Free Press, an imprint of Simon & Schuster.

THE HOMEBOY WAY

**From Thomas Vozzo,
CEO of Homeboy Industries**

Blending personal stories of his day-to-day with Fr. Greg and the Homies along with counterintuitive business ideas that are changing lives for the better, Thomas Vozzo shows you how you can live, lead, and shake things up with toughness, determination, compassion, and grit.

THOMAS VOZZO
CEO OF HOMEBOY INDUSTRIES

THE
HOMEBOY®
WAY

A Radical Approach
to Business and Life

FOREWORD BY *NEW YORK TIMES* BESTSELLING AUTHOR
GREGORY BOYLE

SHARING THE WISDOM OF TIME

**Basis of the Netflix series
Stories of a Generation**

People of faith from over 30 countries share their wisdom carved from lifetimes of experience. Includes inspiring stories from Gregory Boyle, Martin Scorsese, and others.

SHARING
THE WISDOM OF TIME

BY POPE FRANCIS AND FRIENDS